IMAGES
of America

EAST PEORIA

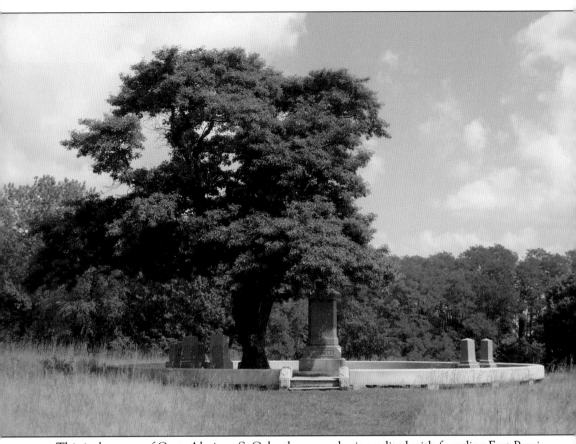

This is the grave of Capt. Almiron S. Cole, the man who is credited with founding East Peoria. He is buried at Springdale Cemetery in Peoria. (Courtesy of Jeanette Kendall.)

ON THE COVER: Gus Belt started Steak 'n Shake in 1934 in Normal, Illinois. The East Peoria Steak 'n Shake, located at 1150 West Washington Street on the bank of the Illinois River, was the sixth built in the chain. After several remodels, the original building was torn down in the early 1990s. This photograph shows the waitstaff at the East Peoria Steak 'n Shake in the 1950s. Steak 'n Shake is still in operation today along the Illinois River. The new building is located just to the right of where the former restaurant was. (Courtesy of Joe Haynes.)

IMAGES
of America

EAST PEORIA

Jeanette Kendall

ARCADIA
PUBLISHING

Published by Arcadia Publishing
Charleston, South Carolina

Printed in the United States of America

Library of Congress Control Number: 2012956241

For all general information, please contact Arcadia Publishing:
Telephone 843-853-2070
Fax 843-853-0044
E-mail sales@arcadiapublishing.com
For customer service and orders:
Toll-Free 1-888-313-2665

Visit us on the Internet at www.arcadiapublishing.com

To my parents, Connie (Kestner) Bartley and Jim Kendall, with love.

CONTENTS

ACKNOWLEDGMENTS

When Arcadia Publishing sent me an email in March 2012 saying they were looking for someone to do a historical picture book about East Peoria, I jumped at the chance. I have always wanted to get a book published—and my mom has always prodded me to do so. I thought this would be the perfect opportunity. In my job as an editor and reporter for the *East Peoria Times-Courier*, I cover East Peoria, the very town I collected information on for the book. In the decade I have worked covering the community, I have developed relationships with its people. I can honestly say that East Peorians are very easy to work with, very friendly, and helpful. They are also very proud of the community in which they live. So, first and foremost, I would like to thank the people of East Peoria, especially those who donated photographs for this book or who helped in any way, whether it was offering encouragement, providing some information, or giving me a lead to track down.

Special thanks to East Peoria firefighter Garry Grugan (EPFD), who gave me guidance and many photographs; Fred and Judy Kraus, who own Eysal's Coffee Roasters, where I collected and scanned photographs for four months; and Don Bell, for letting me borrow equipment for the project and helping me scan photographs. A special thanks also goes to Dave Marshall, who did research for this book, and to the East Peoria Historical Society (Ila Ahten and Frank Borror), for providing me with information and some photographs and for letting me scan photographs at their building. Special thanks also to Linda Norvel, who looked up addresses in city directories for me; Rebecca (Davis) Powell, for tracking down information and people; and John Broshears, for giving me valuable information that led to some neat photographs.

Thanks to all who submitted photographs, including the East Peoria Chamber of Commerce, East Peoria Community High School, the East Peoria Fire Department, and the City of East Peoria.

Thanks also to my boyfriend, Tim, for being patient and understanding throughout this yearlong project.

INTRODUCTION

How do you explain to an outsider what East Peoria is all about? The first thing to note is that East Peoria is entirely separate from Peoria. Many think that with the name East Peoria, it is just an extension of Peoria, but that is not the case. East Peoria is its own entity. It is a city that has grown and evolved from the blue-collar industrial town I knew as a child in the 1970s to a progressive city today. And, before my time, according to details provided by old-timers, the town was once basically a mud pit with taverns spread throughout. In other words, not much to look at.

East Peoria was rich in coal, and many coal mines were located throughout the city, which attracted men for work. Then, in the early 1900s, Holt Manufacturing came to East Peoria. This company later became Caterpillar. This had a profound effect on the city, as many people relocated here to follow work. Houses sprang up and the town grew. Naturally, as more people inhabit a town they need services, such as schools, churches, and places to shop, so these places developed as well. In fact, it seems East Peoria grew too fast and experienced some growing pains. This was evident if you tried to drive through the city during rush hour when Caterpillar employees got off work. The traffic was backed up for miles at what is known as the four corners, and if there was also a train at that time—forget about it.

East Peorians know about the frustrations of traffic. They also know about the frustrations of floods. East Peoria is located on the Illinois River, and this has its pros and cons. Of course, it is beautiful. There is nothing quite like driving over one of the two major bridges between East Peoria and Peoria and seeing the water, sprinkled with a few sailboats, glistening under the sun. The river is also great for commerce. But, if there is a harsh winter with much snow, come spring time, that snow melts and the river inches its way up, up, up. East Peoria also has Farm and Cole Creeks snaking through the city, and those can go from a trickle to rapids after a storm. The early settlers had to deal with the hardships of Mother Nature and her floods. Some still talk about the horrible floods in 1927 and 1943. Over time, reservoirs were constructed to combat this issue, and, today, the flooding is contained along the river's edge. However, some businesses along the river still deal with flooding issues.

As a child, the delights of East Peoria were going with mom to the Velvet Freeze, where they had mugs of root beer, or to Steak 'n Shake, where they had curb service and a shake with a cherry on top. We also had happy times at Farmdale Park, where you could drive your vehicle across the concrete slabs that went through the creek. That was really something unique.

The Franklin Street drawbridge was another East Peoria icon, and one that terrified me. I had nightmares about falling into the river when the drawbridge lifted. That bridge is only a memory now, as it was replaced with the Bob Michel Bridge.

Obviously, my memories are only one viewpoint from a specific time period, and others' memories of East Peoria are going to vary according to their decades there. Each person has his or her own special set of memories.

But I have lived in East Peoria long enough to see a city transformed. I once shared the same sentiment as the old-timer who described the city as not much to look at. But, that viewpoint has changed. The city fathers have taken a bleak, largely industrial town and transformed it into an urban hot spot. In fact, the greatest transformation is now under way, with an entirely new downtown being developed on about 88 acres in the heart of the city. It is an exciting time in East Peoria.

There is one thing about East Peoria that has surely held true from the time it was founded and even before: its charm. There is no denying the quaintness of the town, as it is nestled in a valley surrounded by gorgeous bluffs and beautiful trees. To drive along Route 24 or Route 116 and see the bluffs in the fall is breathtaking, and, surely, the Native Americans and French settlers who were here so long ago felt the same way.

Hopefully, this book will provide those who look through its pages with some happy memories or insights into this interesting town. The collection of photographs is just a glimpse of the life and times of East Peoria and is in no way a definitive collection.

One

PEOPLE

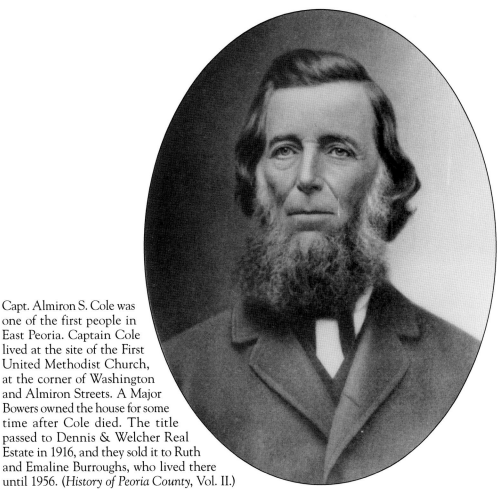

Capt. Almiron S. Cole was one of the first people in East Peoria. Captain Cole lived at the site of the First United Methodist Church, at the corner of Washington and Almiron Streets. A Major Bowers owned the house for some time after Cole died. The title passed to Dennis & Welcher Real Estate in 1916, and they sold it to Ruth and Emaline Burroughs, who lived there until 1956. (*History of Peoria County*, Vol. II.)

This is the former site of the A.S. Cole Distillery in East Peoria. There was a big spring in the back of the house. Today, references to Cole are found in East Peoria through its streets, such as Cole Street and Cole Hollow. (Peoria Historical Society, Fondulac District Library.)

This is the home of the Frey family, at 110 Gold Street. According to the Peoria city directory, the family was living here in 1906. Seen here are, from left to right, Mamie, Elsie, and Roy Frey. Gold and Silver Streets were in the vicinity of where Aldi is today. (Jim Frey.)

The garage at 100 Cole Street, where the Frey family lived, is seen here in 1933 or 1934. From left to right are Jack Jr., Bob, Jack, Elsie, William, Mamie, Esther, Marilynann, and Roy Frey. (Jim Frey.)

William Leroy "Roy" Frey was born in 1893 in Pekin, Illinois. He moved to East Peoria in the early 1900s, living on Gold Street, and, later, at 100 Cole Street. He attended school until eighth grade. He traveled as a musician to tent shows and on riverboats such as the *Julia Belle Swain*. He later served in the Army during World War I. (Jim Frey.)

Roy Frey was a professional musician for 48 years. He performed at the Hippodrome and the Majestic in Peoria, which later became the Palace and Madison Theaters, respectively. He played in vaudeville, the Peoria Symphony, and the Peoria Municipal Band. He is seen here about 1905. (Jim Frey.)

William Frey, the Fondulac tax collector, is seen here in 1915. He was active in the community and was on the original sanitary district board in East Peoria, which started in the early 1930s. He was born on July 19, 1869, in Geneseo, Illinois. He died on December 10, 1948, in East Peoria. (Jim Frey.)

It is believed that this photograph is of Elsie Frey dressed up like Annie Oakley at her McKinley Avenue home in East Peoria. Elise was born in 1903 to William Frey and Mamie Thomas Frey. Elsie later married Jack O'Brien and died in 1953 in East Dubuque. (Jim Frey.)

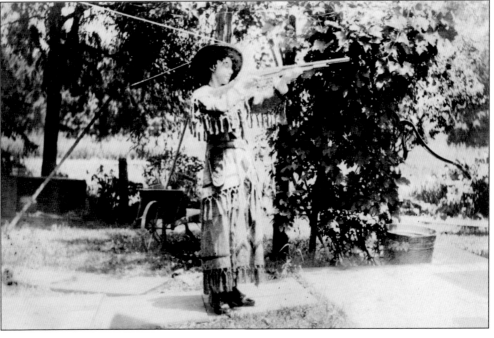

William Frey and his wife, Mamie, pose for a photograph on Sunday, April 14, 1918. By that time, the Freys were well established in East Peoria; their family was mentioned frequently in the local newspapers in the early 1900s. One account in the *East Peoria Post* in 1906 said Mamie Frey entertained a few of her friends on New Year's Eve and served supper at midnight. (Jim Frey.)

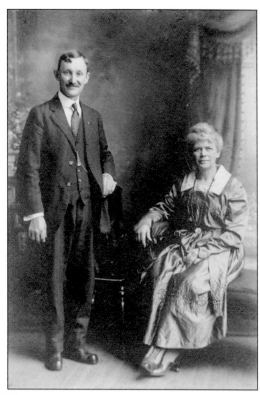

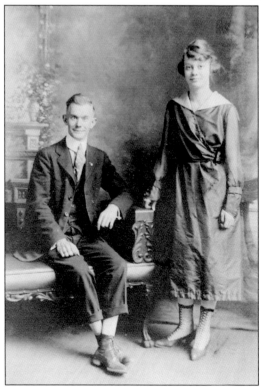

The Frey family had their family portraits taken in 1918. Siblings Roy and Elsie Frey, the two children of William and Mamie Frey, are seen here. (Jim Frey.)

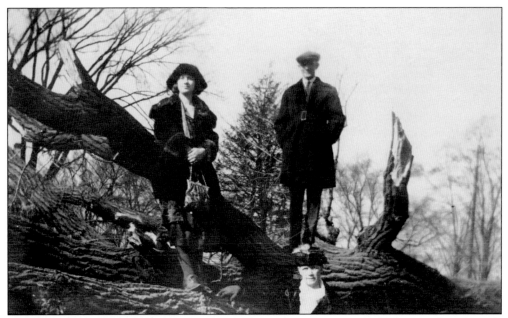

Elsie Frey and her brother Roy stand on a tree that was in the process of being removed at 100 Cole Street in East Peoria. In the foreground is their mother, Mamie. The trees were being removed from the land so that a home could be built. (Jim Frey.)

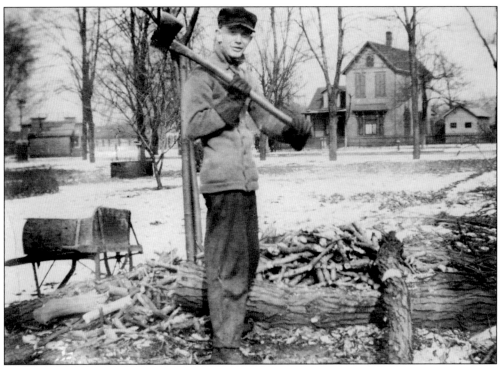

Roy Frey gets ready to work with the axe to help his family remove tree limbs so their home could be built. (Jim Frey.)

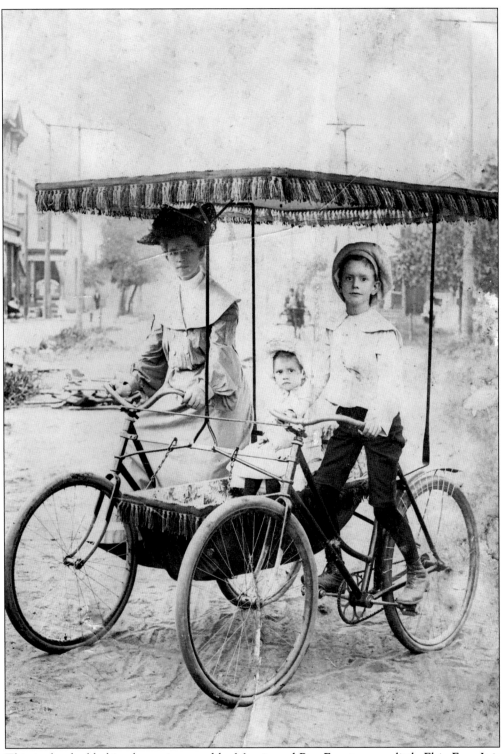

This is the double bicycle carriage used by Mamie and Roy Frey to carry little Elsie Frey. It is complete with a canopy top to keep the riders shaded from the sun. (Jim Frey.)

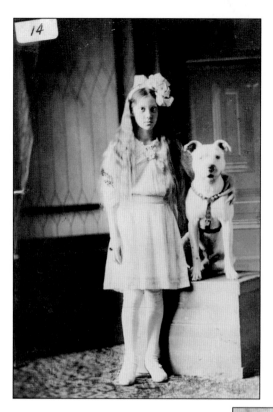

A young Elsie Frey is seen here with a pet. Her style changed in later years. Like many of the Freys, Elsie was a musician, playing the piano and organ. Elsie left East Peoria when she married Jack O'Brien and they moved to East Dubuque. The couple had two children, Jack and Robert O'Brien. (Jim Frey.)

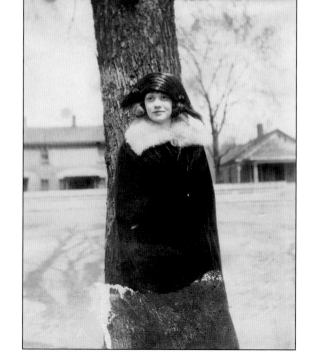

Elsie Frey is seen here dressed in a fancy coat and hat, looking like a movie star in April 1923. Elsie's mother, Mamie, wrote local plays and made all of the costumes. This could have been why Elsie had fancy clothes to dress up in. (Jim Frey.)

Betty and Nancy Brownfield stand in the back of Brownfield's Restaurant and Carroll's Tavern, located at 109 and 107 East Washington Street, respectively. The restaurant was owned by their father, Frank "Brownie" Brownfield, who started the business in 1945. Brownfield purchased the building from John Dean. (Betty Dobbins.)

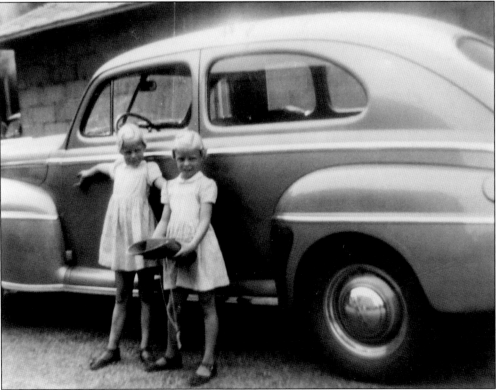

Sisters Betty and Nancy Brownfield grew up in East Peoria and spent a lot of time at their father's restaurant, Brownfield's, which operated for about 40 years. The sisters both later worked at the restaurant. Their mother, Ieleen, was the cashier. Their brother Richard did not work there when his sisters did, as he moved to Nevada. (Betty Dobbins.)

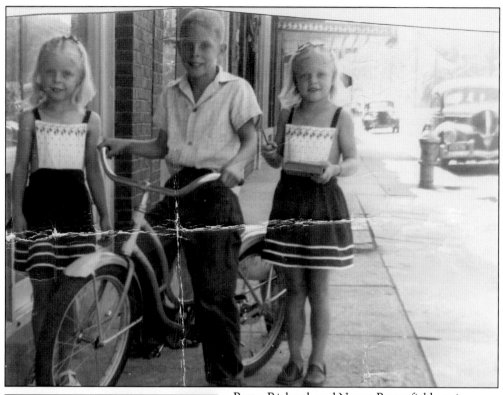

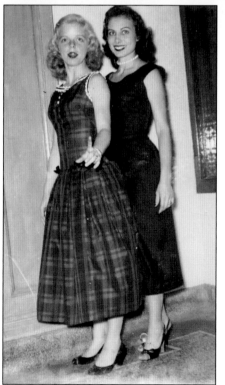

Betty, Richard, and Nancy Brownfield are in front of Brownfield's Restaurant, along East Washington Street. The marquee of the Luxe Theater is behind them. The Brownfield children grew up in downtown East Peoria. They lived above the restaurant for a time before moving to 930 Pekin Avenue. (Betty Dobbins.)

Betty (Brownfield) Dobbins (left) and Earleen Barnes pose for a photograph before the homecoming dance in 1954. The dance was held in the A Building at East Peoria Community High School, in the old girls' gymnasium. Betty later became a schoolteacher in East Peoria. (Betty Dobbins.)

William O. Sommerfield was born in 1884. His father, William F. Sommerfield, ran a general store with Joseph Shertz. The older Sommerfield later operated his own store, Sommerfield Grocery & Hardware. William O. followed in his father's footsteps. As a young man, he repaired bicycles and sold new ones under the name Sommerfield Specials. (East Peoria Historical Society.)

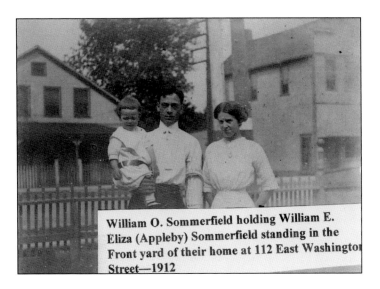

William O. Sommerfield holding William E. Eliza (Appleby) Sommerfield standing in the Front yard of their home at 112 East Washington Street—1912

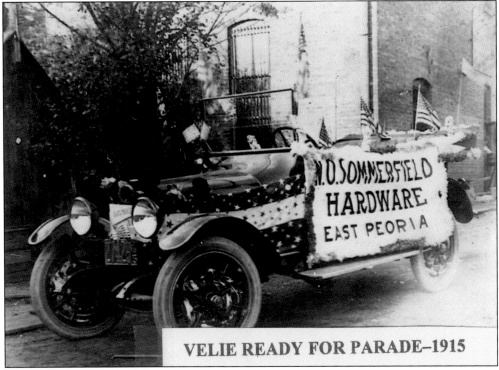

VELIE READY FOR PARADE–1915

William O. Sommerfield was a prominent citizen of East Peoria, so it is no surprise that he participated in a town parade. He took over the family business in 1908 and focused on the hardware aspect, eliminating groceries. He served on the school board and the city council and was then mayor of East Peoria from 1933 to 1939 and 1942 to 1947. (East Peoria Historical Society.)

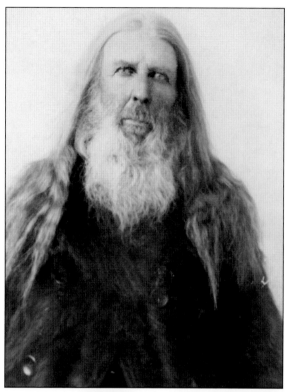

Jack Sheppard, known as "Uncle Jack," is seen here in the late 1800s. He lived between Dixon's and Spindler Marina in a cabin along the Illinois River. He was known as a hunter and trapper. He settled in Tazewell County as a young man when Native Americans were still in the area and was a member of the Peoria Old Settler's Association. (Jack Blair.)

Jack Sheppard is seen here with his wife, Barbara. The two referred to their home as a museum, and people visited there and listened to Jack tell stories about his artifacts. Jack lost a political bet when James Buchanan became president, so he did not cut his hair or beard for more than 50 years. He died in 1903 and is buried in Secor, Illinois, along with Barbara, who died in 1914. (Jack Blair.)

The Schelms were a well-known family in East Peoria. William H. Schelm moved to East Peoria with his six children in the early 1900s. He then started Kastien & Schelm, a blacksmith and wagon repair business. He also built the Bluebird Theater, the first theater in East Peoria. The theater later caught on fire. (East Peoria Historical Society.)

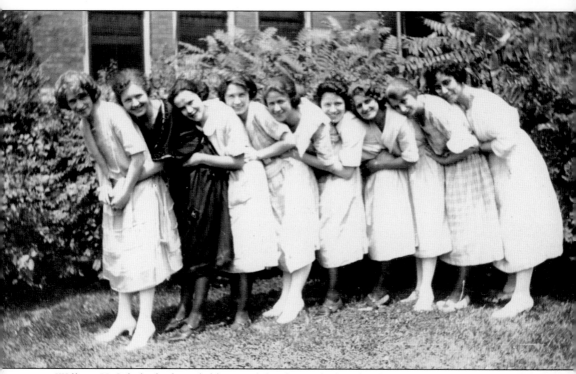

William H. Schelm had six children with his first wife, four daughters and two sons. After his wife died, he married Julia Gerdt and they had two sons. This photograph likely shows his daughters and perhaps some other family members or friends. Their daughters were Hilda, Alma, Ruth Emma, and Viola. (East Peoria Historical Society.)

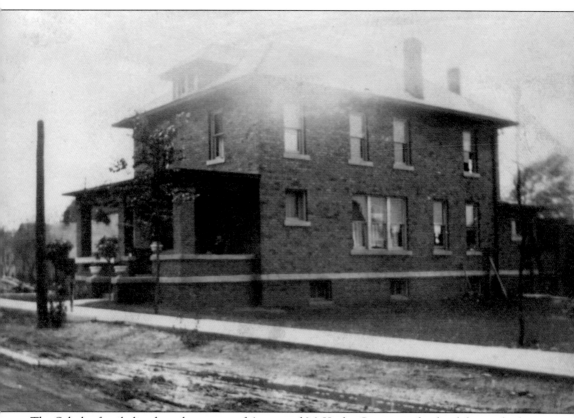

The Schelm family lived on the corner of Anna and McKinley Streets in this brick house, built in 1913. William's two sons from his first marriage, Carl and Paul, joined him in his business. William's second wife, Julia, was elected the first president of the East Peoria Woman's Club in 1935. (East Peoria Historical Society.)

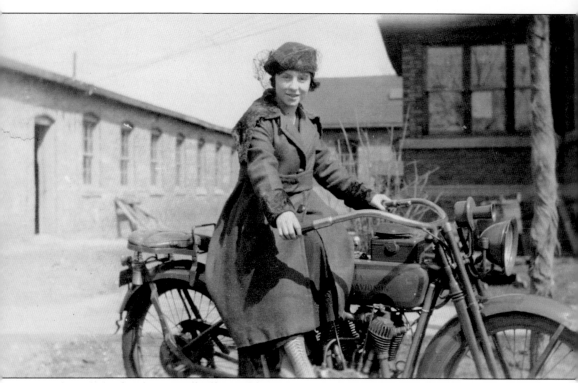

The Schelm family was well off, as evidenced by one of their daughters sitting on this Harley-Davidson motorcycle. The photograph appears to have been taken in front of their home, at the corner of Anna and McKinley Streets. (East Peoria Historical Society.)

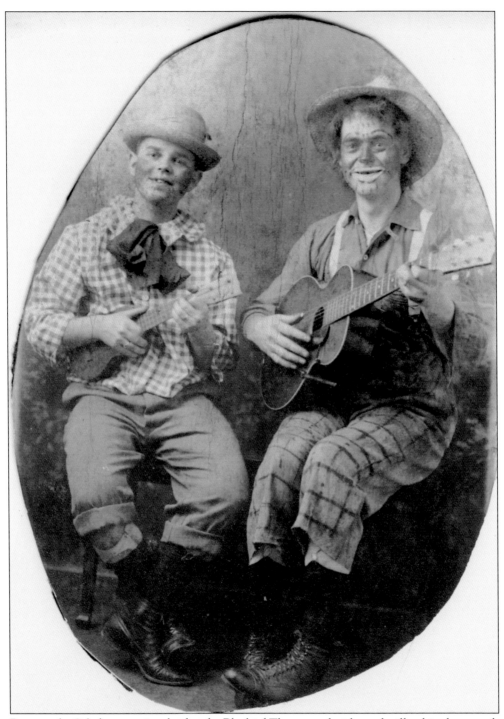

Because the Schelms were involved at the Bluebird Theater and with vaudeville, this photograph is likely from one of those acts. It may even be of two of the Schelm brothers. William Schelm had two sons, Carl and Paul, with his first wife and two more, Alfred and Harold, with his second wife, Julia. (East Peoria Historical Society.)

Dr. Fred Stiers was a prominent figure in East Peoria. He began his practice in Peoria but moved to East Peoria after he was persuaded by Mr. and Mrs. C.F. Lilly, who owned a drugstore near the four corners. Initially, he rented a room above the drugstore until he expanded his practice at 521 East Washington Street, where Remmert Funeral Home is now located. (Ila Ahten.)

Fred Stiers married Lillian Carol Ulrich in 1909. The newlyweds moved to a home at 531 East Washington Street. That home had belonged to a Dr. McFall before the Stiers family moved in and stayed for the next 50 years. (Ila Ahten.)

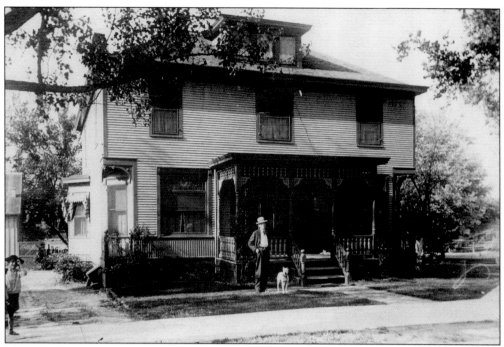

The Stiers home, at 531 East Washington Street, still stands near Central Junior High School, and is owned by George and Kathy Whitman today. The home served as a residence and as Dr. Stiers's practice. When he began treating patients, Dr. Stiers made house calls with a horse and buggy. According to an East Peoria Historical Society newsletter, he mostly treated farmers and coal miners. Dr. Stiers died in 1959. (Kathy Whitman.)

Fred and Lillian Stiers had two children, Carolyn and Fred Jr. Carolyn was born on May 11, 1911, and Fred Jr. was born April 17, 1913. The siblings were close their entire lives. Carolyn had a love of music and played in the high school band. She began teaching at Richland School in 1934 and was a lifetime member of the Organ Guild. (Ila Ahten.)

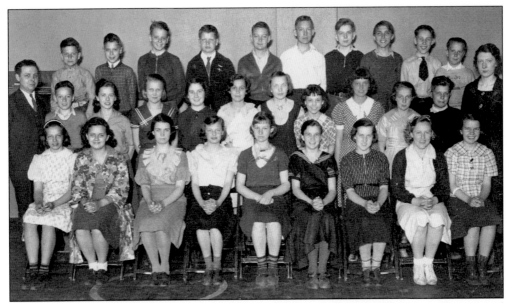

After high school, Carolyn Stiers continued her education at Bradley University. She majored in public school music and her minor was the organ. She graduated from Bradley in 1933. She taught at several schools in East Peoria, including Richland School, Washington Grade School, Central School, and Jefferson School. She is seen here, on the far right, with one of her classes. (Ila Ahten.)

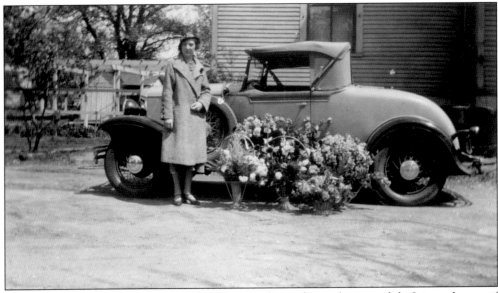

Carolyn Stiers poses amongst bouquets of flowers in front of an early automobile. It is not known if the car was hers or her father's. Dr. Fred Stiers bought his first car in 1912, but he kept his horse and buggy because he said they were more dependable to get through the dirt roads. (Ila Ahten.)

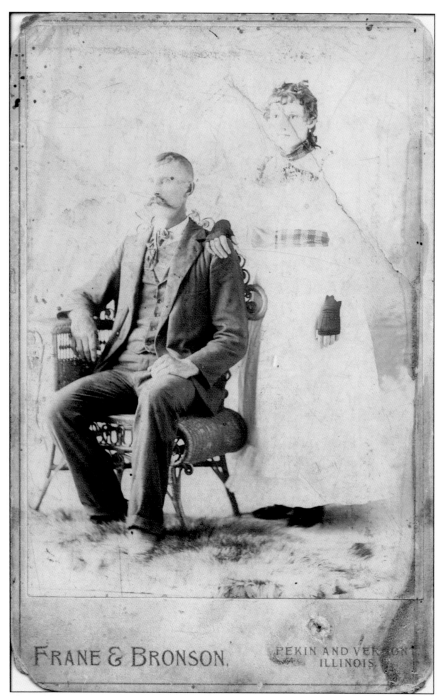

FRANE & BRONSON. PEKIN AND VE__ON ILLINOIS.

Alexander Nelan is seen here with his daughter, Nettie Alzada Frances Nelan. Alexander was the great-grandfather of local resident Linda Norvel. He fought in the Civil War and is buried at Fondulac Cemetery. The photograph was taken sometime before Nettie married in 1901 and looks to be from the late 1800s. Alexander Nelan was born in Bridgeport, Belmont County, Ohio, on February 13, 1837, and died in East Peoria on April 22, 1913. This is the only known photograph of him. (Linda Norvel.)

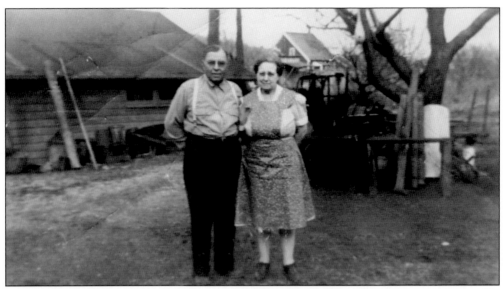

Curtis William Bell was born on October 3, 1890, in Kirksville, Adair County, Missouri. He married Opal M. Gardner on November 17, 1913, in Macon, Missouri. They moved to East Peoria in 1919 with their three oldest children. In the late 1930s, he moved to 1216 East Washington Street and opened up a tractor and automobile repair business called Happy Bell's Service. His father was Clyde Curtis Bell, who was born and died in Adair County, Missouri. (Don Bell.)

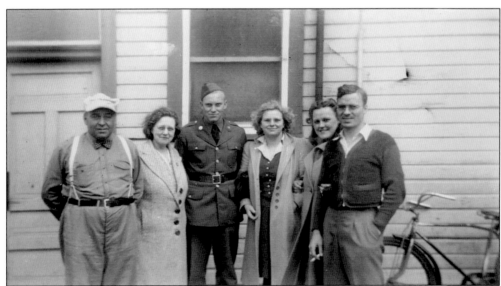

Curtis and Opal Bell are seen here with their children, from left to right, Earl, Mildred, Mary, and Harry. The family first lived at 225 Schertz Avenue, and Curtis worked at International Harvester as a mechanic and salesman before starting his own business. They first moved to 1216 East Washington Street and then to Center Street. (Don Bell.)

Tommy Thompson, the owner of the Manhattan mine, is seen here in his automobile in East Peoria in 1929. East Peoria had several coal mines. The Manhattan mine was located on Cole Hollow Road. Thompson and his wife, Hazel, lived at 118 Cole Street. Thompson's office was at 139 East Washington Street, where Dick Williams's law office is located today. Tommy Thompson died in 1965. (Martin Crane.)

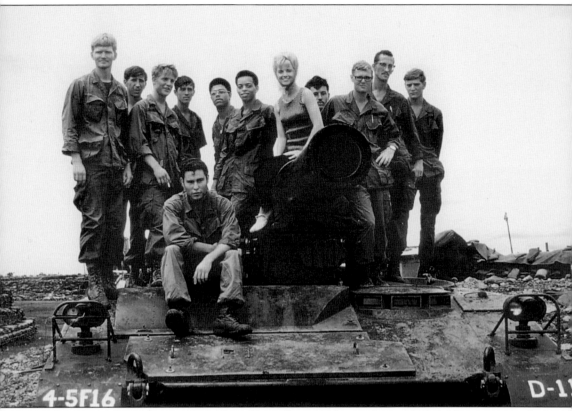

Country and gospel singer Cristy Lane (born Eleanor Johnston), one of 12 children, was raised in East Peoria and graduated from East Peoria Community High School in 1957. She performed in 120 shows in Vietnam during the 1960s. She received the Country Music Association's Top New Female Singer award in 1979. She performed in her own theater in Branson, Missouri, beginning in the late 1980s. In 2003, she received the Veterans of Foreign Wars Hall of Fame award. Today, she lives in Madison, Tennessee. (James Kunz.)

Two

LIFE IN EAST PEORIA

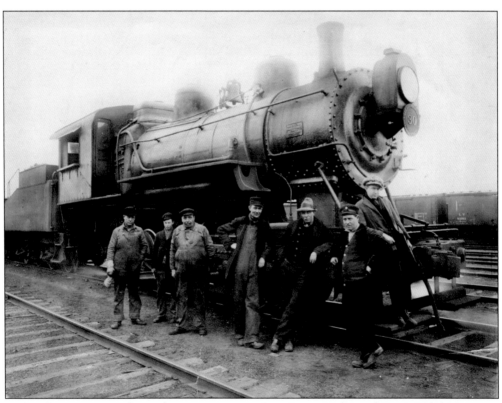

Railroads were a major form of transportation in East Peoria in the mid-1800s and their impact is still evident today. This photograph shows workers on the Toledo, Peoria & Warsaw (TP&W) Railroad around 1920. East Peorian Ray Densberger is on the far right. According to *The Centennial History of East Peoria*, the Peoria & Oquawka Railroad (P&O) first built a railroad in East Peoria in 1853. The tracks went from the new town of Fondulac to Chenoa and began operating in 1857. In 1861, one portion of the P&O was sold and another portion was sold in foreclosure to the Toledo, Peoria & Warsaw. This train went all the way across the state. In 1880, there was another sale, and the name of the railroad was changed to the Toledo, Peoria & Western. (Gary and Jana Densberger.)

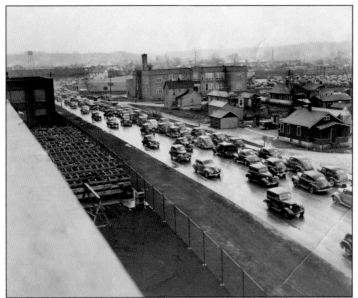

Here, traffic is backed up on Cedar Street, likely due to workers going to their jobs at Caterpillar or elsewhere in Peoria. The date of this photograph is not known, but it appears to be in the 1930s or 1940s judging by the cars. Caterpillar buildings are in the left foreground. On the right are residences and what appears to be Roosevelt School, which was demolished in 2010. (Charles "Jug" Anthony Jr., Fondulac District Library.)

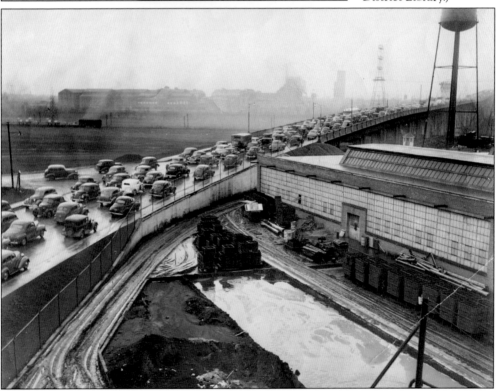

Caterpillar was a major employer in the area and brought many families to East Peoria. The factory is seen here in the 1930s or 1940s. According to *The Centennial History of East Peoria*, the company had its first net loss, of $13.3 million, in the early 1930s because of the Depression. Business picked up again however, and by 1936 it had surpassed its 1929 record of $51.8 million in sales. Between 1925 and 1929, employment at the company had risen from 2,537 to 6,875. (Charles "Jug" Anthony Jr., Fondulac District Library.)

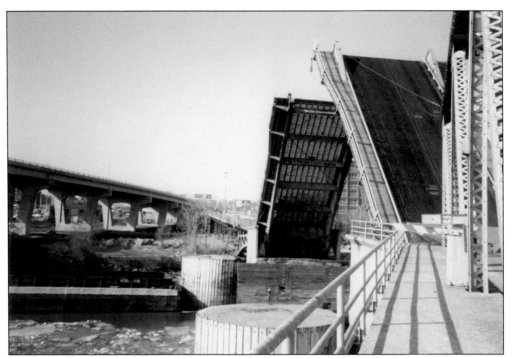

Construction on the Franklin Street Bridge began in 1907, and the bridge opened on April 11, 1909. According to information from the bridge monument, the bridge had interlocking steel leaves that could be raised by a set of electrically powered gears and pinions to allow barges to pass through. On May 1, 1909, all spans from the East Peoria approach to the lift span collapsed into the river and the bridge had to be rebuilt. (Robert Hunt.)

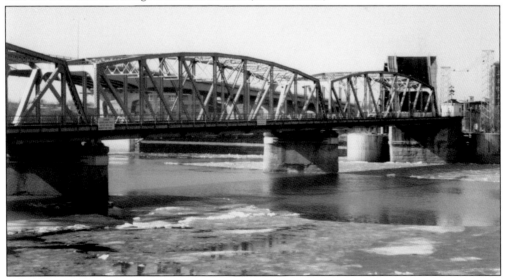

In 1959, ownership of the Franklin Street Bridge was transferred from the city of Peoria to the Illinois Department of Public Works (now the Illinois Department of Transportation). In 1993, the bridge had run its course after 82 years of service. It was dismantled and the Bob Michel Bridge was constructed in its place. A monument to commemorate the bridge was dedicated in 1998. (Robert Hunt.)

Being situated near bodies of water like Farm Creek, Cole Creek, and the Illinois River has its pros and cons. East Peorians learned of the cons early on, as flooding was common before reservoirs were constructed. What was likely the worst flood occurred in May 1927, although there were floods recorded prior to that. During the 1927 flood, Caterpillar, Altorfer Bros., city hall, and many homes and other businesses were damaged. (Steve Sary; Emery Sary collection.)

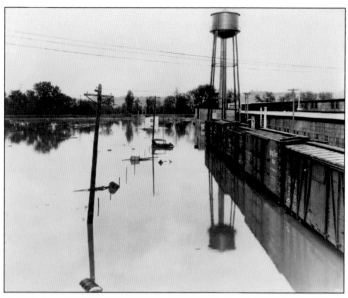

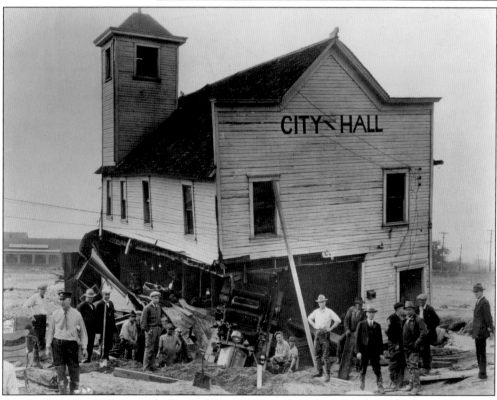

City hall, at North Main and Herschel Streets, was washed out by the 1927 flood. Here, the building is being held up by a tall wooden stilt. After the flash flood took place and damage estimates were announced at $2 million, the East Peoria Sanitary District was formed to begin a new flood-control program, according to *The Centennial History of East Peoria*. Emery Sary, who had a large collection of flood photographs in East Peoria, worked at the East Peoria Sanitary District. (Steve Sary; Emery Sary collection.)

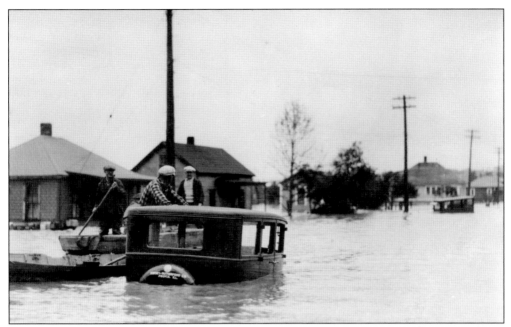

This photograph gives a good indication of just how high the water was, as this car is almost completely engulfed. This photograph was taken at Edmund Street between Monson and Sanford Streets. Today, it is hard to imagine the hardships East Peoria residents had to endure because of flooding. (Steve Sary; Emery Sary collection.)

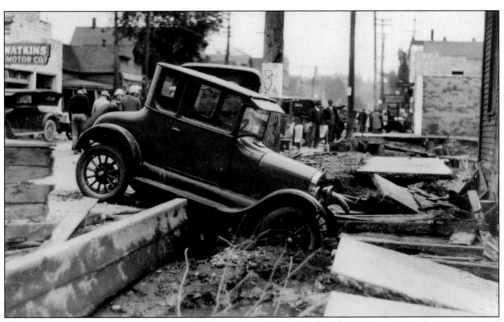

This vehicle was apparently swept off the road due to the floodwaters. It must have remained there for some time, as the water had receded by the time this photograph was taken on West Washington Street. Despite efforts to combat flooding, another flood ravaged East Peoria in 1943. Dams were constructed after World War II, and East Peoria has not witnessed another serious flash flood since that time. (Steve Sary; Emery Sary collection.)

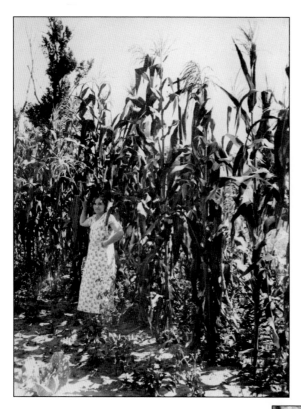

Nettie Edwards grows corn in East Peoria at 217 Anna Street. Nettie, the aunt of local resident Linda Norvel, was married to John William Edwards, who was the building commissioner. Her corn was featured in a local newspaper because it grew to be 11 feet tall. John William Edwards died in 1945 and Nettie Edwards died in 1948. This photograph is thought to have been taken in 1940. (Linda Norvel.)

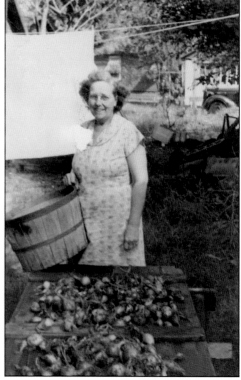

Opal Bell of East Peoria shows off the onions she grew in her garden. Growing one's own fruits and vegetables was popular in past decades, especially if a family grew up during the Great Depression or lived through wartime. (Don Bell.)

Life in East Peoria was not all work and no play, and when hardworking families needed a break, they could go and listen to popular bands such as the Frey band, seen here in 1897. From left to right are William Frey, Mamie Frey, Roy Frey, and Frank and Gennie Armstrong. Roy Frey was just a young boy when he got into the music scene with his parents. Roy, Jim Frey's father, was a professional musician who played in the area for 48 years. (Jim Frey.)

GRAND BALL

GIVEN BY

FRYE'S
ORCHESTRA

Saturday Evening, February 19, 1910,

at East Peoria Hall.

Tickets 50c. per Couple. Extra Ladies Free.

In the early 1900s, going to a ball to dance the night away was a common form of entertainment. This is one of the flyers from the Frey band's concerts. The family's name was misspelled on the announcement. The concert was held on February 19, 1910, at East Peoria Hall. By today's standards, 50¢ per couple is quite a bargain, but it was pricey in 1910. (Jim Frey.)

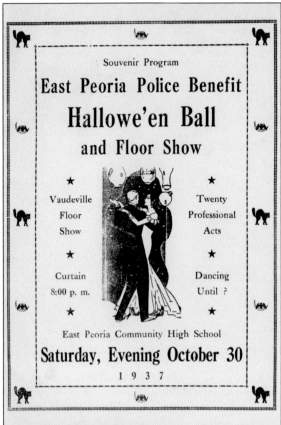

Souvenir Program

East Peoria Police Benefit
Hallowe'en Ball
and Floor Show

★ ★

Vaudeville Twenty
Floor Professional
Show Acts

★ ★

Curtain Dancing
8:00 p. m. Until ?

★ ★

East Peoria Community High School

Saturday, Evening October 30
1 9 3 7

East Peoria police and firefighters presented residents with fun evenings out by putting on benefit dances. This is the book cover of a souvenir program from an East Peoria Police Department benefit ball and floor show on Halloween in 1937. The event included 20 professional acts at East Peoria Community High School. (Bill Hoey.)

The Harry Bell Band played around the East Peoria area in barns and different venues. The Bell family lived in East Peoria. Don Bell of East Peoria submitted this photograph of his grandfather Harry's band. Many in the Bell family were musically inclined. Curtis "Happy" Bell, Don's great-grandfather and Harry's father, played the banjo. In addition to playing out and about, they also played at home. "Anytime I went to my grandma and grandpa's house he was playing the fiddle or someone was singing," Don Bell recalled. Harry Bell kept playing his fiddle until he died in 1980. Both he and his father are buried at Fondulac Cemetery in East Peoria. (Don Bell.)

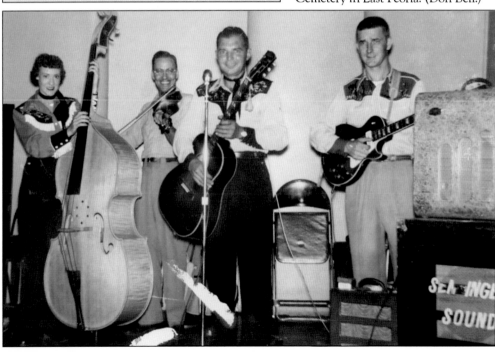

This photograph from about 1950 shows local Boy Scout Troop 164 and the Cub Scouts, of which Robert Hunt (second row, fifth from left) was a member. The Scouts got to tour Caterpillar's factories in downtown East Peoria. The Cub Scouts wore knickers and hats. The group was sponsored by the Methodist church in Washington. (Robert Hunt.)

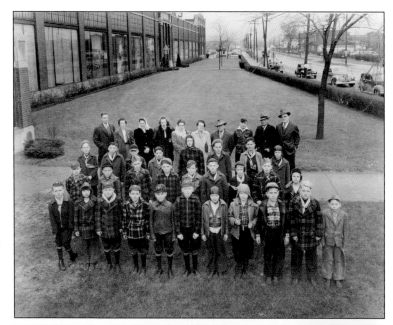

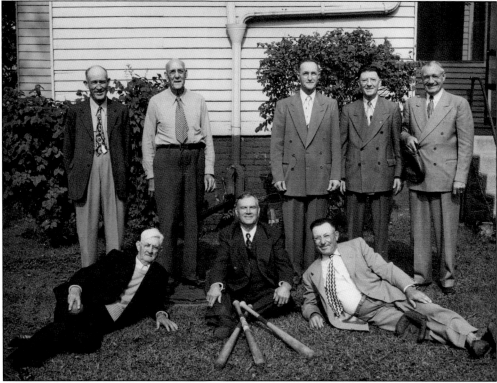

In addition to dancing at balls, going to the movies at the Bluebird Theater, and joining local organizations, East Peorians also played sports. The town's first baseball team, the East Peoria Sluggers, began in 1903. In 1907, the Sluggers became the Pirates. From left to right are (first row) John Harris, Tom Callihan, and William Carius; (second row) Ed Tucker, John Hoffman, William Mauschbaugh, Martin Coogan, and Louie Carius. (Steve Sary; Emery Sary collection.)

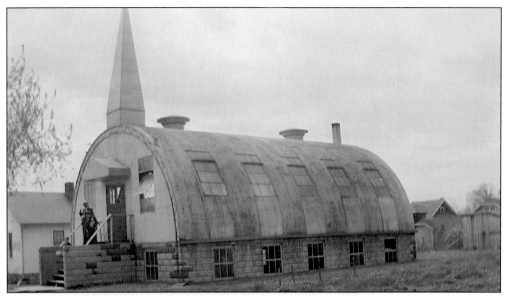

In 1932, Rev. S.J. Grabil, district superintendent of the Missionary Church Association, conducted a tent meeting on Route 24 near Leadley Avenue and talked of starting a church in East Peoria, according to information from church historian Emma Johnson and the *East Peoria Fall Festival Book*, September 1950. A lot was purchased on Leadley Avenue, and a basement church was erected. A steel-roofed Quonset hut was transported by river barge from the Chicago area to East Peoria. On November 14, 1937, Bethany Missionary Church, known as the Little Steel Church, was dedicated. Bethany Missionary Church is pictured during Easter 1937. (Bethany Missionary Church.)

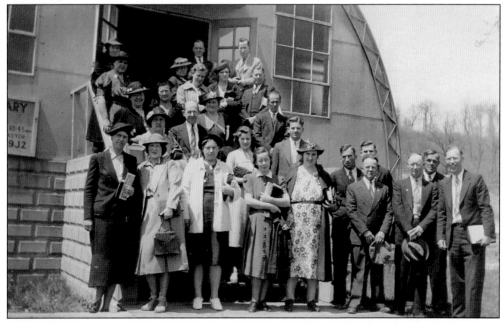

This is the original congregation at Bethany Missionary Church. Sunday school services started on December 6, 1936. The structure still stands today on Leadley Avenue, and is the current home of the Last Harvest Ministries Church. (Bethany Missionary Church.)

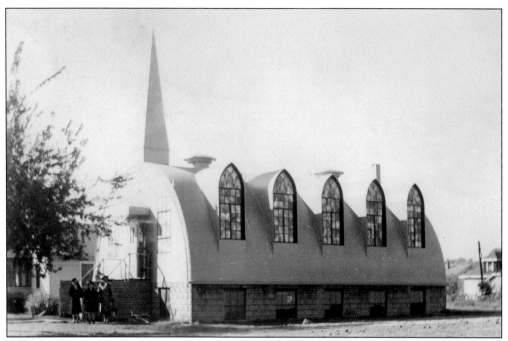

Bethany Missionary Church is seen here in the 1950s, as evidenced by the newer stained-glass windows installed on the side of the building. Ron and Don Davis attended church here. (Rebecca Davis Powell.)

In 1907, the Christ Lutheran and Trinity Lutheran Churches of Peoria established a Lutheran school at the corner of Cole and Everett Streets in East Peoria with 35 students. The school was later demolished and the site used for the new Fondulac District Library. The library then moved to 140 East Washington Street. In 1910, the Lutheran community purchased a building at the corner of Cole and Everett Streets, directly across from the Lutheran school. This building was the former home of a German Methodist church. The new church was called St. Peter's Lutheran Church and the first minister was Pastor Ernest Duever. The church began with 13 members signing the church constitution. A new church building was subsequently completed at 200 Cole Street and dedicated on Nov. 7, 1947. St. Peter's Lutheran Church celebrated its 100th anniversary in 2010. (St. Peter's Lutheran Church.)

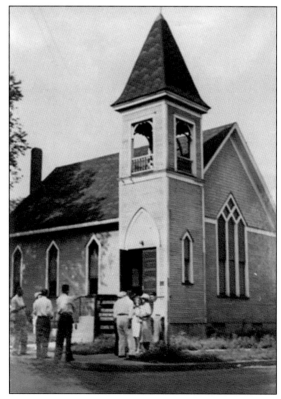

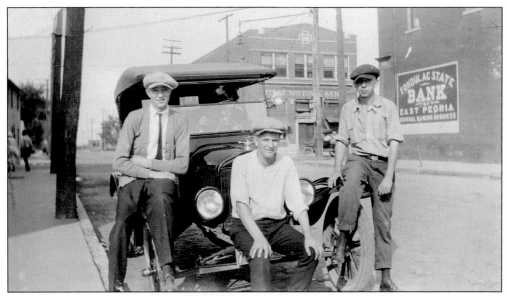

A large part of life in East Peoria in the past was going downtown to shop or simply hang out with friends. This photograph was taken by the four corners—Main and East Washington Streets—in downtown East Peoria in 1923. First National Bank and Fondulac Bank are seen in the background. The men's hats were the style at the time. John Edwards is seated on the car in the middle. The other two men are his friends. The license plate has a "23" on it, dating the photograph to 1923. (Linda Norvel.)

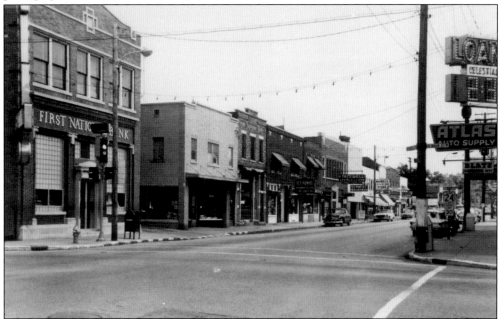

Downtown changed significantly from 1923 to the 1950s. By that time, banks, grocery stores, dime stores, theaters, hardware stores, and restaurants could all be found downtown. This photograph, looking down East Washington Street at East Peoria's downtown in the 1950s, shows Brownfield's Restaurant, Tazewell Savings & Loan, Schmidt Insurance, and Waibel's dime store. (Betty Dobbins.)

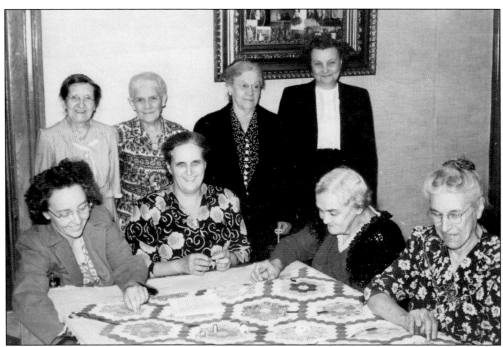

In past decades, women would meet in each other's homes once a week to make quilts. This photograph was taken in the 1940s at 154 East Washington Street. Standing from left to right are Annie Hersman, Mamie Frey, Stella Harvey, and Sarah Doering Ehrett. The first three women sitting down are not identified, but on the far right is Emaline Burroughs, whose home the photograph was taken in. Jim Frey said that as a young boy he would play under the table and pick up the needles and thread the women dropped. (Jim Frey.)

Houses were mostly built with brick in the early-and-mid-1900s. This house was built in 1921 by John Wilson Hartz, who was the head of Couch & Heyle Engineers in East Peoria. The house was known as the Hartz-Wald Estate. *Wald* is a German term meaning "woods." This estate had more than five acres, and the house has a commanding view of the river and retains many of its original features. Ann Stinnett's parents bought the property from the widow of John Hartz in the 1960s. Information about the home was provided by Jean Grube of Peoria, the granddaughter of John Hartz. (Ann Stinnett.)

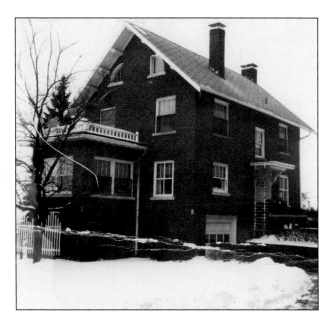

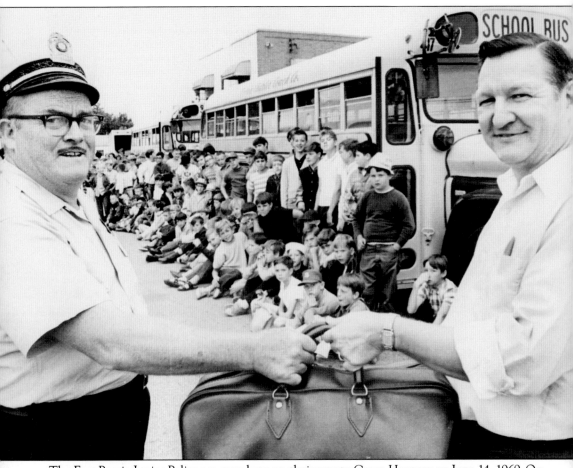

The East Peoria Junior Police are seen here on their way to Camp Haugerg on June 14, 1969. On the right is Jim Spinder, a former mayor of East Peoria. Mayor Spinder's son James C. Spinder II was in the junior police. Mayor Spinder was elected commissioner in 1959. He was then elected mayor in 1967 and served two terms. In a letter, he said that there were 725 junior police members. Boys between the ages of 9 to 16 joined the group to learn and play together. (Evalyn Spinder.)

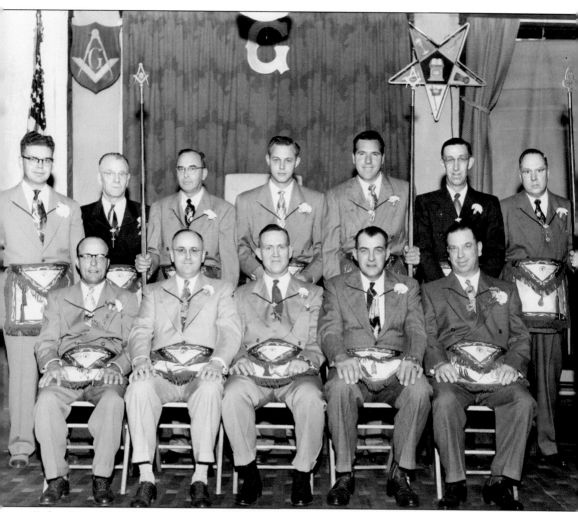

Today, East Peoria has many clubs and organizations, such as the Rotary Club, Kiwanis Club, the East Peoria Woman's Club, and the East Peoria Historical Society. One long-standing club in East Peoria is the Masonic Hilton Lodge 1143, which meets at 230 Pekin Avenue. The group was formed in 1925 and chartered in 1926. This photograph shows the officers of that group more than 30 years ago. (Bill Hoey; photograph by Charles Owens.)

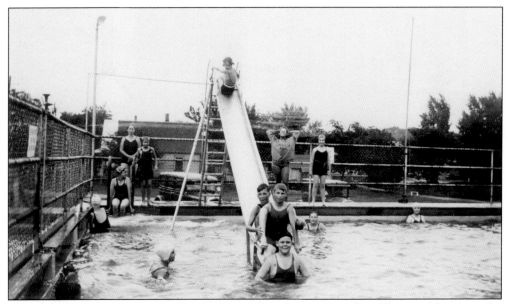

Swimming was a fun activity for East Peoria youth on hot summer days. They could swim at the Fondulac Pool, seen here in July 1933. This was the first pool in East Peoria, located on Cole Street near St. Peter's Lutheran Church. The girl with her arms behind her head is Dorothy Davis, who served as a lifeguard. The boy in front of the slide is Eugene Davis. (Rebecca Davis Powell.)

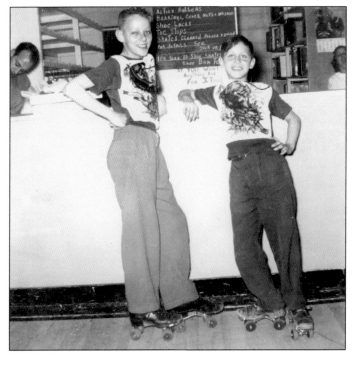

Roller-skating was very popular in the 1950s. The Dobbelaire family owned and operated Roller Gardens in East Peoria. Jack and Dorothy Dobbelaire started the construction of Roller Gardens in 1950 and opened for business on March 10, 1951. The rink was located at 215 North Main Street, next to city hall and the police station. The rink was operated by the Dobbelaires for 25 years. Seen here are Chuck Dobbelaire (left) and his brother Hopp. Chuck later became the mayor of East Peoria. (Charles Dobbelaire.)

The East Peoria centennial in 1984 was a big occasion, with many celebratory activities. As seen on this sign at East Peoria Community High School, the celebration took place from June 29 through July 3, with activities downtown and at the high school. One of the events was a parade. Another event was the dedication of the bell tower in downtown East Peoria. (Barb Bullock.)

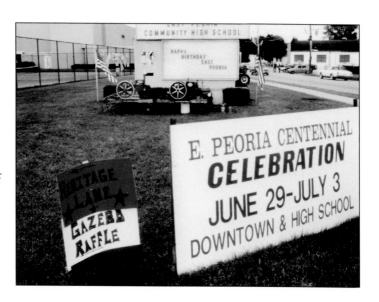

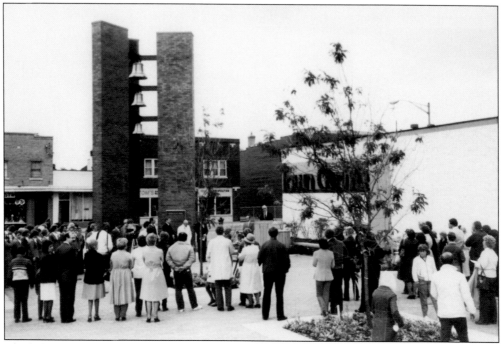

The bell tower in downtown East Peoria was dedicated as part of the centennial celebration for East Peoria. James Ranney, the mayor at the time, likely spoke at this event. The bell tower has a plaque on it that reads "East Peoria Centennial 1884–1984." It also has another plaque that tells the history of the city. Prior to 1884, East Peoria was composed of two settlements, Blue Town and Coleville. In 1884, these towns incorporated into Hilton. In 1889, it became the Village of East Peoria, and, in 1919, the name became what it is today, the City of East Peoria. (East Peoria Chamber of Commerce.)

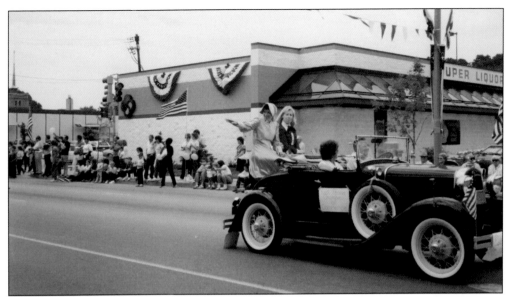

A parade was part of the festivities for the centennial celebration in East Peoria. People dressed up in clothing from past decades for the occasion. Here, an unidentified woman waves from an old car sponsored by the East Peoria Chamber of Commerce. This photograph was taken on West Washington Street in front of Town Centre. (East Peoria Chamber of Commerce.)

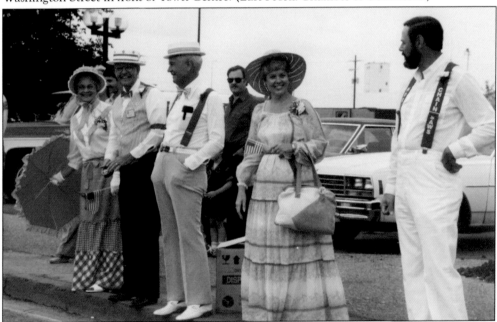

People dressed up in clothes from the past stand on the side of the road during the parade in downtown East Peoria. These residents may have taken part in the parade, judging by their attire. The East Peoria Centennial Commission was made up of Maurice Joseph, Bob Ward, Ken Littrell, Homer Dewey, Alice Giacoletti, Marge Creek, Jo Dobbelaire, Tim Riggenbach, Peg Bahnfleth, Wanda Johnson, Marilyn Davis, Marilyn Leyland, Virgil McGlothlin, Bob Peffer, Norma Smith, Karen Dodson, Mike Miller, Priscilla McCarthy, Letha Scheerer, Ken Tofanelli, Bill Riddle, Kim Johnson, and Cheryl Bury. (East Peoria Chamber of Commerce.)

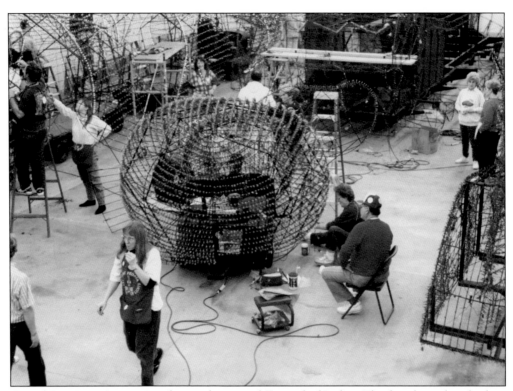

Out of East Peoria's centennial grew the annual Festival of Lights. The first festival took place in 1985. The idea for the Christmas event is credited to Ron Scott, who was the manager of the Holiday Inn in East Peoria. Scott saw a similar festival in New York and brought the idea to East Peoria. Volunteers began working on floats for a parade of lights at a red warehouse in the city known as the Festival building. According to an article about the history of the Festival of Lights by Pam Dewey and Jill Peterson, the members of the commission formed committees to work on the Festival of Lights. They chose a toy wooden soldier as the mascot for the festival. His name is Folepi, which stands for Festival of Lights East Peoria, Illinois. (City of East Peoria.)

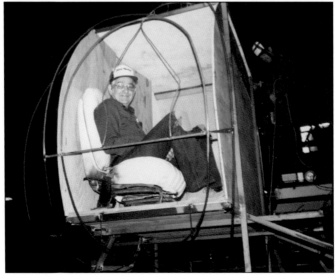

Wally Jaquet was one of the first of the volunteers to help build the floats for the Festival of Lights parade. He volunteered his time and talents for more than 25 years, designing and welding many of the floats from scratch. He is seen here inside one of the floats in its early stages. (City of East Peoria.)

The first floats for the parade were made of fiberglass and plywood. There were seven original floats, including this Frosty the Snowman float. About 30,000 people attended the first parade. The parade has come a long way since then. Frosty the Snowman has long since been retired, and floats are made much differently now, with steel frames. In 2012, the floats were refurbished and they now feature LED lights. (City of East Peoria.)

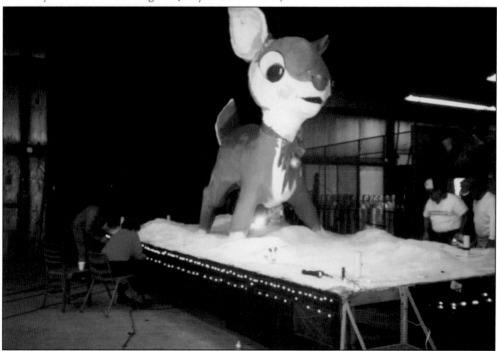

The first floats were chosen from popular Christmas songs such as "Frosty the Snowman." There were also floats based on "Silent Night," "Jingle Bells," "Silver Bells," "Winter Wonderland," and "Here Comes Santa Claus." (City of East Peoria.)

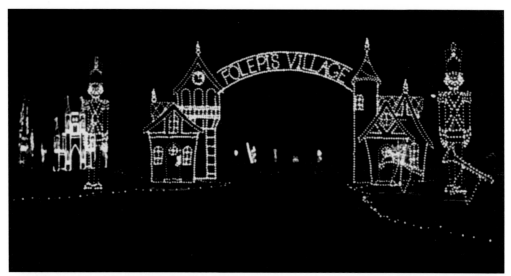

In 1993, stationary floats were displayed at a new attraction called Folepi's Winter Wonderland, a drive-through electric park. Today, that attraction brings thousands of visitors to witness the spectacle at the park, located off Springfield Road. The American Bus Association named this attraction one of the top 100 events in North America several times, according to Pam Dewey and Jill Peterson's article "History of the East Peoria Festival of Lights." (City of East Peoria.)

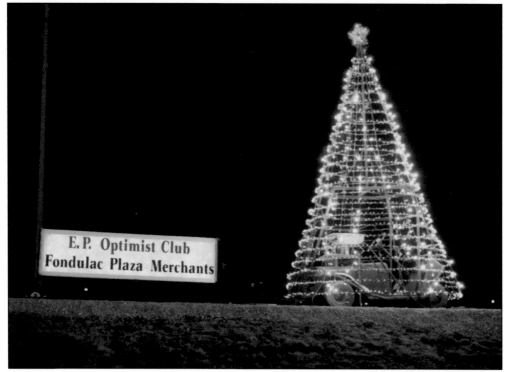

To help offset costs, businesses sponsored floats, as seen in this photograph at the Winter Wonderland. The East Peoria Optimist Club and the Fondulac Plaza Merchants sponsored this lighted Christmas tree display. This tradition continues today. The Festival of Lights celebrated 25 years in 2009. (City of East Peoria.)

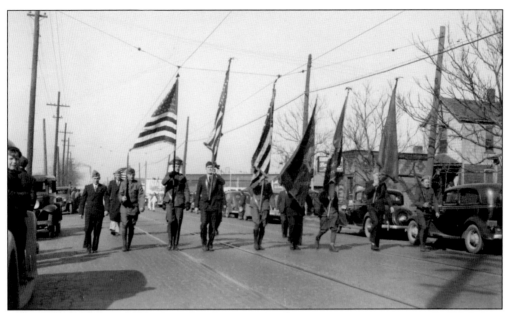

Many news articles in early *East Peoria Courier* newspapers talk about East Peoria's Armistice Day parades. That appears to be what this parade is, since the participants are dressed in military outfits and carrying flags down West Washington Street. The time period appears to be the late 1930s or early 1940s, judging by the cars. (Don Bell.)

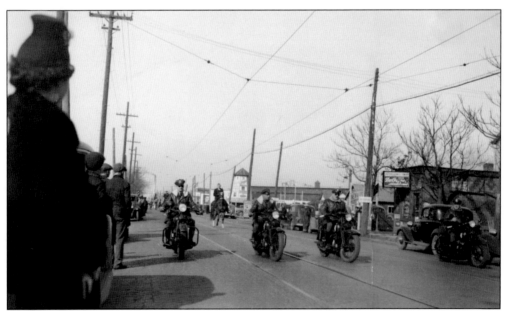

This photograph was taken during the same parade as the photograph above, along West Washington Street. The men on the motorcycles appear to be police officers, judging by their hats. The building in the background that looks like a lighthouse is Roszell's, which sold ice cream, milk, and frozen foods. (Don Bell.)

Three

BUSINESS

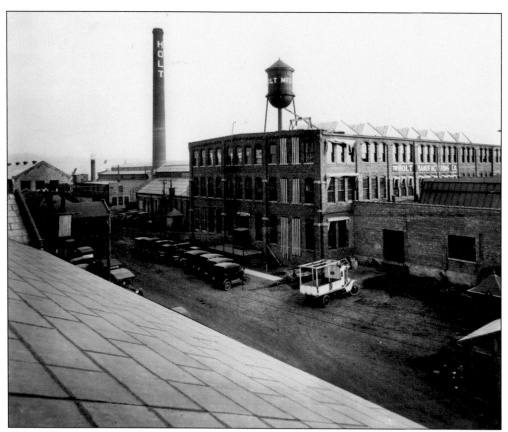

Murray Baker, an agricultural equipment dealer in Peoria, was largely responsible for getting Caterpillar to move to East Peoria. In 1910, the company was called Holt Co., based in California, and looking to expand in the Midwest. According to *The Centennial History of East Peoria*, Baker contacted Pliny E. Holt and informed him of the Colean plant, which was for sale in East Peoria, and the rest is history. (Fondulac District Library.)

Workers are seen here outside the Holt tractor plant in East Peoria. The date is unknown. Labor unions began organizing campaigns for the workforce in the 1930s. According to *The Centennial History of East Peoria*, "On June 10, 1948, the National Labor Relations Board certified the UAW-CIO as the new bargaining agent and United Auto Workers Local 974 was organized with temporary quarters in a trailer next to the Anthony Grocery Store on West Washington Street." (Fondulac District Library.)

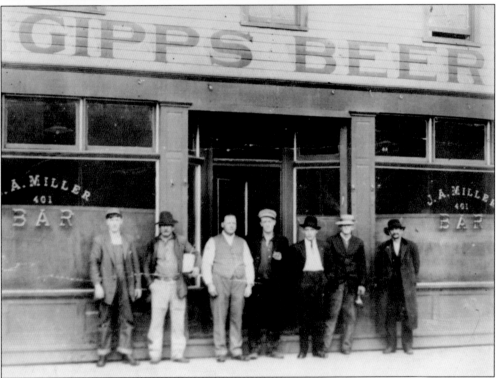

Considering that Peoria was once known as a whiskey capital because of all of its breweries and distilleries, it is no surprise that there were many taverns in East Peoria in the early days. One of them was the 401 Bar, seen here. Gipps Beer was a brewery in Peoria, and the advertisement on the building shows how prominent it was at the time. The date of this photograph is unknown, but it is thought to be from around 1900. Ginger Brodt's father, Louis Billmeyer, owned a bar and had a collection of photographs of old East Peoria taverns. Some of the men in this photograph are, in no particular order, John Payton, Nate Swords, Art Miller, William Mushbaugh, and Peter Franks. (Ginger Brodt.)

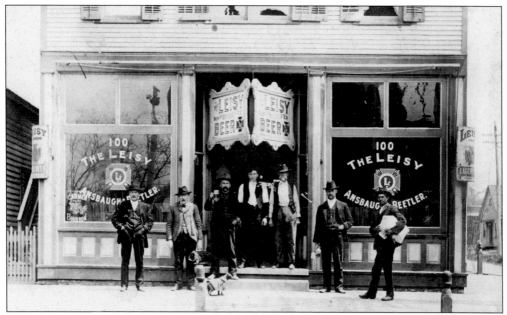

This photograph was also part of Louis Billmeyer's collection. It is of an early East Peoria bar. The Leisy Brewing Co., advertised on the window, was based in Peoria. According to the Peoria Historical Society, Albert and Edward Leisy's brewery began in 1884 and was sold in 1920. Ginger Brodt, who donated this photograph, believes that this spot later became Bob Miller's tavern, on East Washington and Main Streets. (Ginger Brodt.)

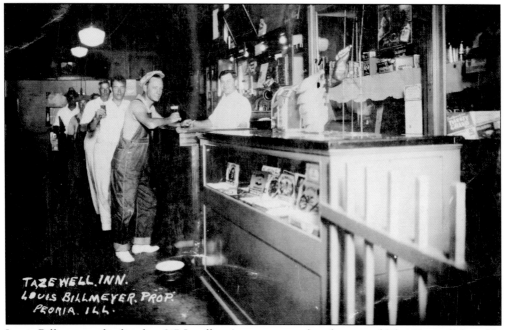

Louis Billmeyer, who lived at 317 Leadley Avenue, owned and operated The Tazewell Inn. He was in business for 25 years. His last year in business was either 1957 or 1958. Louis is standing behind the bar in this photograph. Standing at the bar in the hat and overalls is Bob Miller, who ran a tavern at East Washington and Main Streets in East Peoria. (Ginger Brodt.)

Louis Billmeyer is seen here behind the bar at his tavern in July 1941. The Tazewell Inn was next to where the Variety Club is now located, on West Washington Street. Billmeyer also owned a building across the street, where Tucker's Barbershop and Peterson Jewelry were located. He wanted to move his bar there, but it was too close to the Methodist church. That building is no longer in existence. (Ginger Brodt.)

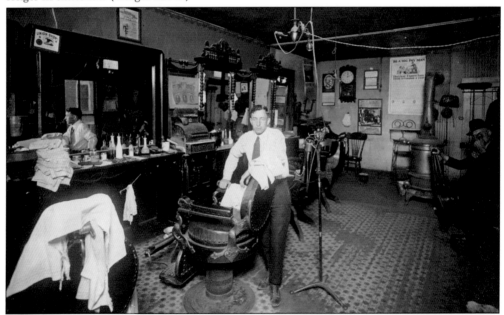

Levi S. King was born in 1895 and married in 1918. A barber by trade, he had a business on East Washington Street, next to where Beck's Florist is today, called Levi S. King's Barbershop. However, King was never called by his first name; his friends knew him as Peewee. Note the sign on the mirror on the left that says "union shop." Also note the spittoons on the floor and the picture of the presidents under American flags on the wall. (Connie Jo Farrah Habecker.)

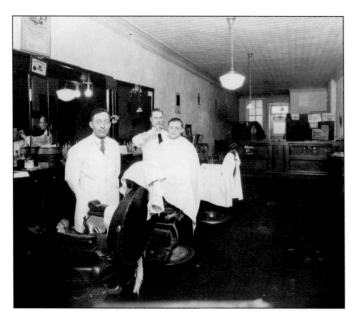

This photograph of the interior of Levi S. King's Barbershop is very different from the photograph on the previous page. It was taken in the late 1920s. There are more modern light fixtures hanging from the ceiling and the old stove to heat the inside of the room is gone. The same "union shop" sign is hanging on the mirror, however, and a Phil Schmidt calendar is hanging on the wall. Levi S. "Peewee" King is in the foreground. In the background, barber Charlie Lang gives a haircut to a customer. (Connie Jo Farrah Habecker.)

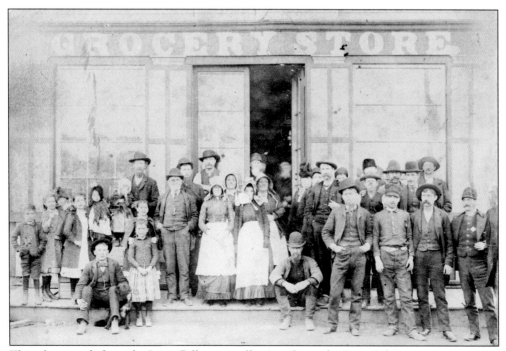

This photograph from the Louis Billmeyer collection shows the Peter Schertz grocery store, at the corner of Bloomington Road and East Washington Street, before 1900. Schertz is standing in the doorway on the left. The hall in the upstairs of the building was used for many years by the Odd Fellows and the Rebecca Lodge organizations in East Peoria. (Ginger Brodt.)

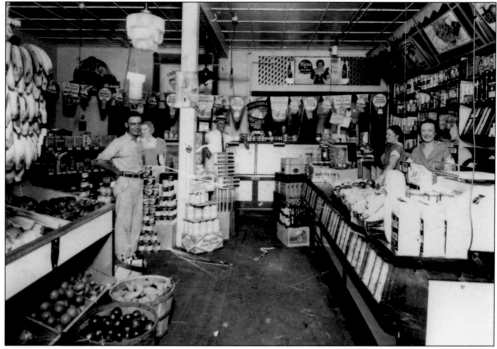

Local mom-and-pop grocery stores were popular in East Peoria before big box stores came to town. This photograph shows Bessie Bradbury's grocery store in 1940. The business was located at 301 East Washington Street, where East Peoria Drycleaners is today. The man on the left is Lewy W. Kunz. Bradbury, the owner, is on the right behind the counter. Note the stalk of bananas hanging to the left. Kunz's son James recalled meeting his father at the store every Friday to help carry groceries to their home on Pekin Avenue. As a treat, they would buy a brick of ice cream to store in their icebox. (James D. Kunz.)

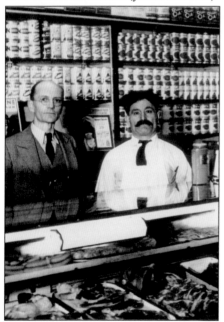

Mike Couri & Sons Groceries & Meats was located at 481 West Washington Street, across from Caterpillar. Mike Couri Sr. is seen here on the right with the moustache. He emigrated from Lebanon in 1907. Also in the photograph is salesman Henry Stedman. The men are standing behind the meat counter. Other canned goods are behind the counter. This was the fourth of Couri's stores. He eventually had six, although they were not all open at the same time. He opened his first store in 1910 in the front room of his Washington Street home in Peoria. In 1925, he decided to start doing business in East Peoria, so he and his cousin Tom Rafool opened the Couri-Rafool Grocery Store at 501 West Washington Street. In 1934, a tavern and restaurant called The Glee Club was built by Couri's son Joseph and added onto the grocery store. In 1935, Joseph also built The Duck Inn Tavern next door, for his aunt Lulu. (Rose Couri Holcomb and Randy Couri; photograph from Joseph M. Couri collection.)

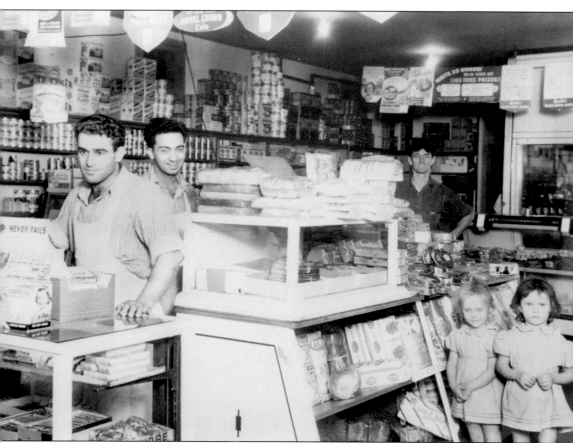

In 1937, Mike Couri and his son Joseph opened a new store, the Mike Couri Complete Food Market, at 1300 East Washington Street in East Peoria. This store was the first self-service store in East Peoria. Customers no longer had to ask a clerk to get their groceries off the shelf for them. Joseph Couri ran this store until he was drafted into the Army. During World War II, Cecelia and Sie Couri ran the store. Other family members also worked at the store. Today, Couri's License & Title Service, owned by Jamil and George Couri, two of Mike Couri's grandsons, is housed in the old grocery store. Although the street is now East Washington Street, it was called Junction Street when the store was built. Pictured in 1938, from left to right, are Joseph Couri, his cousin Joe Joseph, and customer Jack Dobbelaire, whose little girls Verna, two, and Dolores, four, are in the foreground. The store closed in 1950 when the Couris opened a larger store across the street. McDonald's was located on the site of the former grocery store until it moved to its current location at the bottom of Illini Drive. (Rose Couri Holcomb and Randy Couri; photograph from Joseph M. Couri collection.)

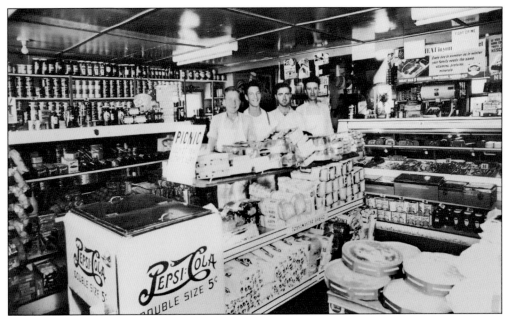

Ray and Frances (Brodt) Densberger owned and operated Densberger Market from the late 1930s until it closed in 1955. It was located at 208 South Main Street, where Aldi's parking lot is today. The family lived near the four corners in East Peoria for 52 years. Seen here in the late 1930s or early 1940s are, from left to right, Ray Taylor, Bill Taylor, Melvin Densberger (Ray's son), and Ray Densberger. (Gary and Jana Densberger.)

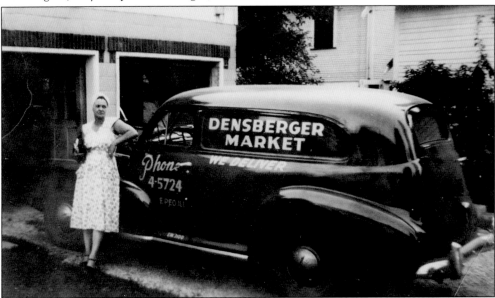

Here, in the late 1930s or early 1940s, Frances Densberger (1900–2000) stands next to the panel truck that was used to deliver groceries from Densberger Market. Note the five-digit phone number on the door of the truck. Ray Densberger (1897–1970) also worked at Herschel Manufacturing Co. for 22 years. He was a busy man, as he also had the grocery store and delivered coal from East Peoria mines to homes, at a cost of $2 per ton. Customers would get three or four loads a year, according to *The Centennial of East Peoria*. (Gary and Jana Densberger.)

William E. Sommerfield followed in the footsteps of his father, William O. Sommerfield, becoming involved in the family's business just as William O. had with his father, William F. Sommerfield. William E. joined his father in 1929 and added electrical supplies, appliances, and electrical contracting to the business at 110 East Washington Street. The store's name was changed to Sommerfield Hardware & Electric, according to a newsletter by the East Peoria Historical Society. William O. retired in 1972. In 1946, Robert Sommerfield joined the business. In 1979, William E. and Robert sold the business to Bije Sherwood. The business later relocated to 219 Junction Street, and the former location was purchased by the city and razed. Sherwood's business eventually closed in the early 2000s. (East Peoria Historical Society.)

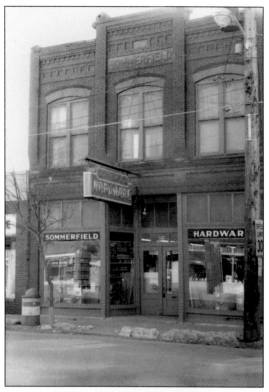

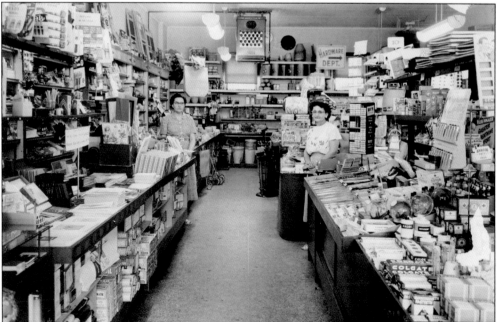

Another popular business that has gone by the wayside was the dime store. East Peoria had two: Sommerfield's and Waibel's. Both businesses were located downtown. Local resident Dick Dodson's grandmother Elsie Hoffert worked at Sommerfield's until it closed. She later worked across the street at Waibel's dime store. (Dick Dodson.)

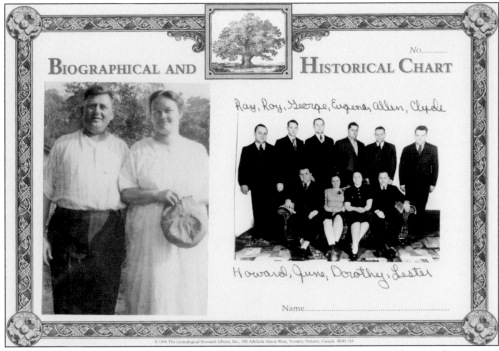

Jasper and Harriet Davis had a large family. All of the Davis children were born at home, in a big two-story house on Dupont Lane behind where Stewart Radio is today. Their children were, from left to right, (first row) Howard (1904–1972), June (1924–1983), Dorothy (1916–1951), and Lester 1913–?); (second row) Ray (1907–1984), Roy (1920–1986), George (1918–1962), Eugene (1911–1960), Allen (1905–1945), and Clyde (1909–1951). Ray, Clyde, and Eugene started Davis Bros. Tap, Howard owned a family shoe store for 20 years in the old section of downtown East Peoria, and Jasper operated a service station for a time where Stewart Radio is now located, at 905 East Washington Street. (Rebecca Davis Powell.)

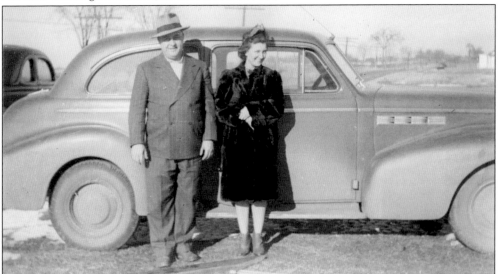

Pictured here in front of their car in 1950, Ray and Pearle Davis were married in 1928. Ray was one of the original owners of Davis Bros. Tap. He died in 1984. (Rebecca Davis Powell.)

Davis Bros. Tap was built in 1949 at 111 North Main Street, near where Hardee's stands today at the four corners of downtown East Peoria. The tavern began with three brothers, Ray, Clyde, and Eugene Davis. Ray Davis was the last of the original owners. After he retired, his sons Ronald V. and Donald R. Davis became the owners. (Rebecca Davis Powell.)

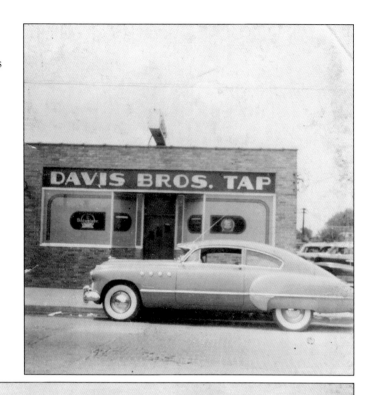

Davis Bros. Tap

TAVERN OPEN 12 TO 4 PIZZA SERVED 12 TO 3

FAST SERVICE ORDERS TO GO

PIZZA - Phone 699-7224

Equipped to handle any order, one up. Also package goods

	Sauce, CHEESE	Sauce, SAUSAGE	Sauce, Cheese, Sausage DeLUXE	Sauce, Cheese, Sausage, Mushrooms SUPREME	Sauce, Cheese, Anchovies ANCHOVIE	Sauce, Cheese, Shrimp SHRIMP
SMALL	$.85	1.10	1.25	1.45	1.10	1.30
MEDIUM	1.15	1.55	1.75	2.10	1.55	1.85
LARGE	1.50	2.00	2.20	2.70	2.00	2.40

Grated cheese, onions and peppers standard, (unless ORDERED withheld)

The staff at Davis Bros. Tap stapled a menu to all take-home pizzas. On this menu from the 1950s, the most expensive pizza was a large Supreme, which cost $2.70. (Rebecca Davis Powell.)

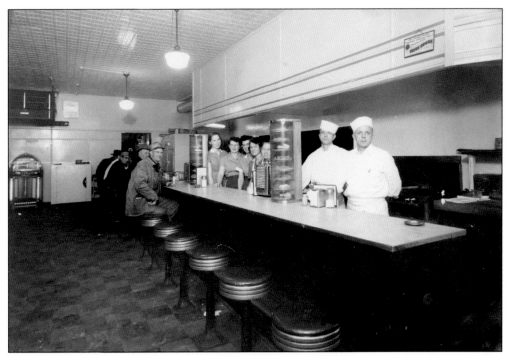

Brownfield's Restaurant was located at 109 East Washington Street. It was owned and operated by Frank "Brownie" Brownfield, who started his business in 1945. Brownfield purchased the building from John Dean. Today, John Dean's name is still spelled out in tiles in the doorway entrance to the building. Brownfield operated the restaurant for about 40 years. (Betty Dobbins.)

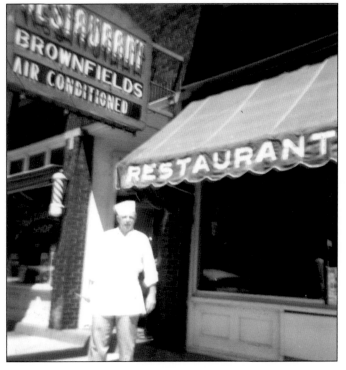

A newspaper article by Carol Gizyn featured a story about Frank Brownfield. The headline read, "A good fry cook is hard to find." A photograph accompanied the article showing Frank flipping something with a spatula. The tagline read, "The Brownfield flip." The most popular lunch dish at the restaurant, according to the article, was stewed chicken and homemade noodles. Eggs and hash browns were popular for breakfast, and cube steaks were often ordered for dinner. Brownfield worked about 14 hours a day serving food to hundreds of hungry people. (Betty Dobbins.)

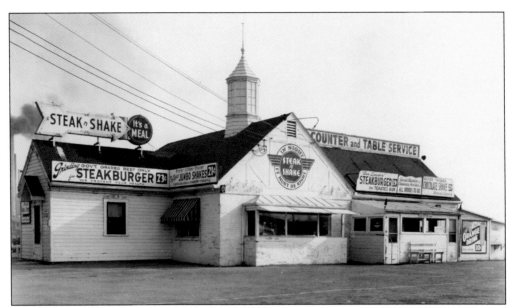

Gus Belt started Steak 'n Shake in 1934 in Normal, Illinois. The East Peoria Steak 'n Shake was located at 1150 West Washington Street, on the bank of the Illinois River, and was the sixth built in the chain. According to a newsletter written by Robert McClelland, who worked there in high school, the building was originally home to the Beacon, a gambling operation and steakhouse. It was renamed the Goal Post before Steak 'n Shake acquired it in December 1939. Over the years the restaurant had three major fires and three major floods, the last in 2013 when the restaurant had to close for a short time. Joe Haynes, a manager and former vice president at Steak 'n Shake, has an extensive collection of photographs of the restaurant, including this one. (Joe Haynes.)

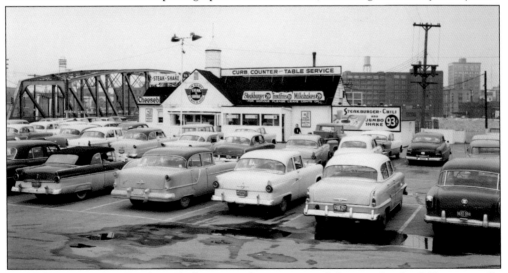

Joe Haynes started at Steak 'n Shake in April 1942 as a curb hop, or "curbie." He eventually became the vice president in charge of all the restaurants in Illinois as well as some in Indianapolis, Davenport, and Moline. He moved to East Peoria in 1950 and spent 35 years with the company. Haynes said that, in the early days, a family could eat for about $1. He added that if he got a quarter for a tip, it was a real "doozie." This photograph was taken in the 1950s, about the same time Haynes moved to East Peoria. (James Flaniken, Steak 'n Shake Enterprises.)

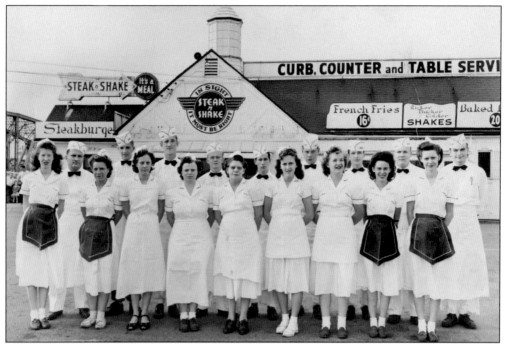

The waitstaff at the East Peoria Steak 'n Shake in the 1950s included, from left to right, (first row) Penny Nichols, Evelyn Noe, unidentified, Jeanette Ball, Laura Hill, Sue Laird, Bet Cowan, Nicki Hewa, and Lee Slavens; (second row) Herb Leonard, unidentified, Fred Long, Joe Haynes, Bob Howard, Jim Morgan, unidentified, Al Walser, and DeWilton Fiedler. Steak 'n Shake is still in operation today along the Illinois River. After several remodels, the original building was torn down in the early 1990s. The new building is just to the right of its former location. (Joe Haynes.)

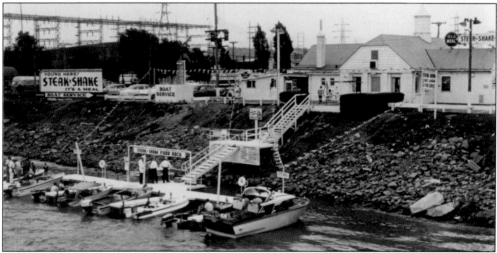

Steak 'n Shake opened in East Peoria in 1940. Sometime after being closed for about 10 days in 1945 due to a flood, the East Peoria store opened a boat dock at the restaurant. The boat dock was open for three years, and in its last year it served over 5,700 boats, according to a Steak 'n Shake newsletter. The boat dock service also made the front cover of a fast food magazine. The boat dock was destroyed by barges that broke loose from the pier and crashed into it during high winds. (Robert Hunt.)

Dixon Fisheries Inc. was founded in 1896 by John and Frank Dixon, who "saw great potential in the fishing industry and the natural resources of the Illinois River," according to the Dixon Fisheries website. The business, located at 1807 North Main Street, is now in its fourth generation of Dixon family ownership. It was originally at the foot of Liberty Street in Peoria before moving to East Peoria in 1967. In the 1950s and 1960s, the third generation of owners became seafood specialists, serving restaurants, country clubs, and supermarkets throughout the Midwest. Jim Dixon is the current CEO and president. (James Dixon.)

Ross Dixon, of the second generation of owners, purchased land along the river from a farmer. In the late 1920s, ponds were dug out using mules and horses. The ponds, which were fed by artesian wells, were used as holding areas for fish. In just one hour, 10,000 gallons of 55-degree well water flowed through them. The carp fished out of the river were stored in the ponds before being processed and sent to New York. Dixon's was one of the first businesses to bring Florida fish to the market. Eventually, these ponds were opened to the public to fish for a fee. Don Dixon, the late father of Jim Dixon, started renting cane fishing poles to people to fish. The heyday of the public fishing ponds was in the 1950s and 1960s. The ponds closed in 1992 and have since been reopened by a nonprofit group called Hooked on Fishing, which conducts fishing clinics there for children. (James Dixon.)

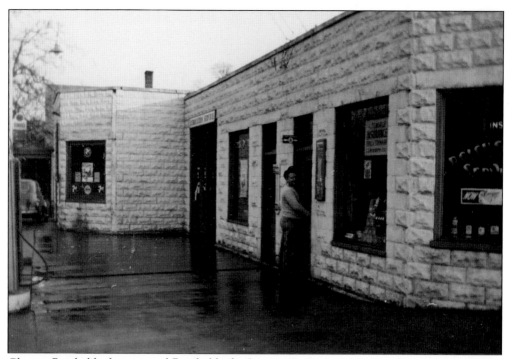

Chester Reichelderfer operated Reichelderfer Service Station, at 400 East Washington Street, until 1952. He also sold insurance. Bill Schoedel worked at the gas station during his last two years in high school. He was then drafted into the Korean War in the late 1940s, serving from 1950 to 1952. When Schoedel returned from the war, he took over Reichelderfer's gas station and it became a Texaco. (Bill Schoedel.)

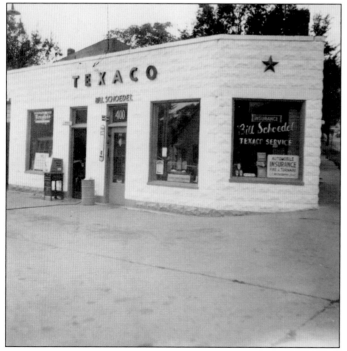

Bill Schoedel was born and raised on Springfield Road, which his gas station was at the base of. He owned and operated the station for 20 years. He recalled that when a right-hand turn lane was added near his business, it took most of his driveway. After he sold the gas station, Schoedel worked as a maintenance man at the high school. Today, Eysal's Coffee Roasters and East Peoria Popcorn are in the location of the former Texaco station. (Bill Schoedel.)

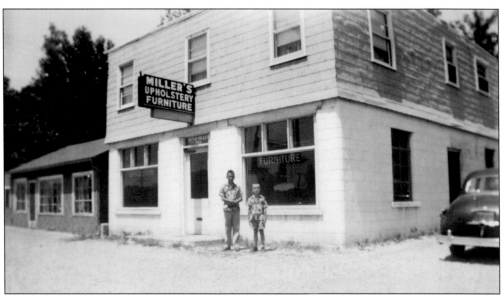

Miller's Upholstery was next to the Cooler Tap, at 713 East Camp Street. Roy and Helen (Hamann) Miller recovered furniture, and, in the early years, also refinished and sold used furniture. After they semi-retired, the business was relocated to their home, at 201 Springfield Road. This photograph was taken in 1950. The business operated from 1950 to the mid-1990s. (Kay Miller Michael.)

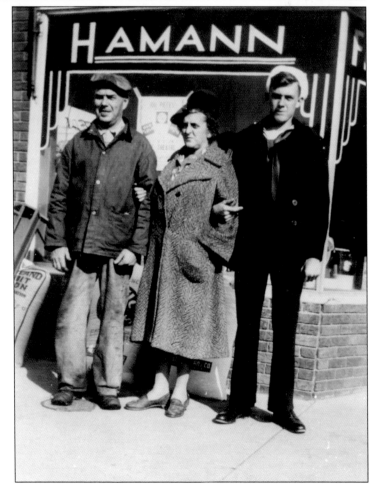

Hamann Feed & Hatchery sold quality chicks, ducklings, turkeys, and other related supplies. The business, at 103 Everett Street, was owned and operated by George Hamann in the early 1940s. George and Hazel Hamann are seen here with their son Robert around 1942. (Kay Miller Michael.)

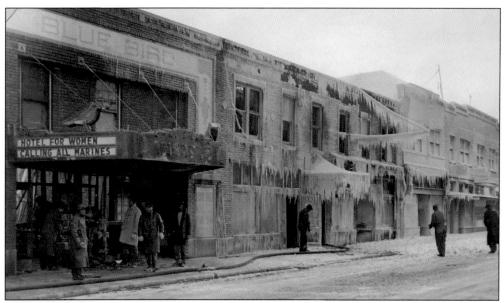

Local historian Robert McClelland wrote in a newsletter that the Blue Bird Theatre opened on January 18, 1922. In an advertisement in the *East Peoria Post*, the theater was described as "a thing of beauty and joy forever." Silent films were shown at the theater. On January 18, 1940, a major fire destroyed the theater. The owner at the time was W. Murlin Ewing. On January 15, 1941, the theater reopened as the Luxe Theater. (Hazel Sutherland.)

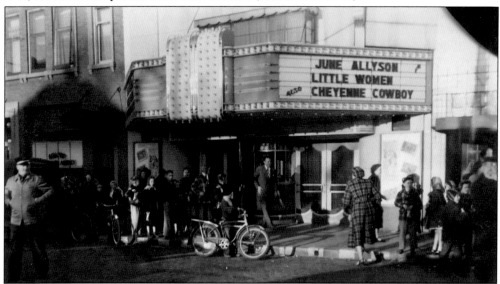

According to local historian Robert McClelland, the Luxe Theater opened on January 15, 1941, with a double feature, *Tom Brown's School Days* and *Moon Over Burma*. An advertisement in the *Peoria Journal Transcript* telling about the new theater read, "This theater is modern in every detail and will endeavor to show the finest in pictures at all times . . . The admission charged will be adults 20 cents and children 10 cents until 4:00 p.m., and after adults 25 cents (plus tax) and children 10 cents." McClelland wrote, "Probably most every western movie I have ever seen other than television was at the Saturday matinee at the Luxe Theater." (Emery and Virginia Sary collection.)

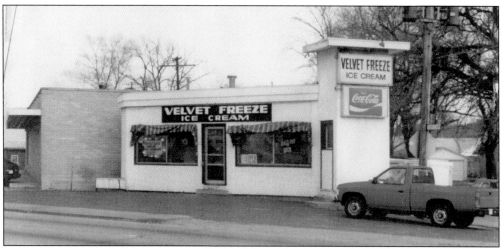

Velvet Freeze was originally on a triangular piece of land fronting East Washington Street. It later moved to Fondulac Plaza and eventually closed on January 26, 2010. Kevin Thomas was the owner when it closed. A new business called Wonderdog then opened in the same spot under new ownership. Velvet Freeze started in Peoria Heights as an ice cream shop, and the 1950s brought its signature Wonder Dog, a chili dog with homemade meat sauce. This photograph of the East Peoria Velvet Freeze in the 1970s now hangs in a hot dog stand called Susie's in Morton. (Susie Perdue.)

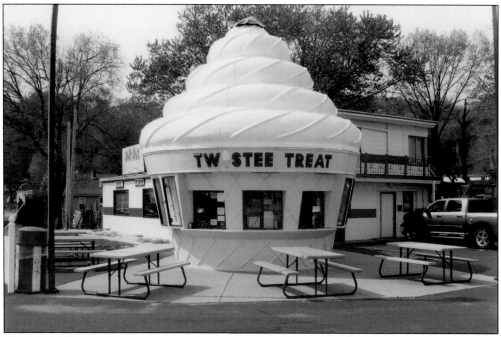

The M&M Twistee Treat is a unique business in East Peoria. Michael Davis owns the ice cream shop at 1207 East Washington Street. According to a 2012 *Pekin Daily Times* article, Davis said that after he got laid off from Caterpillar in 1983, he started an ice cream shop. When the state widened the road 10 years later, he had to demolish the shop. He then ordered the Twistee Treat building from Cape Coral, Florida, and had it shipped. The building was then reconstructed where it now stands. (DeWayne Bartels, *East Peoria Times-Courier.*)

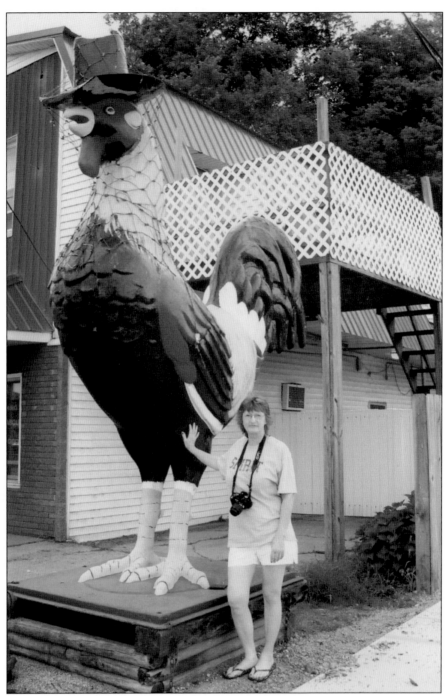

This unique roadside attraction, a giant chicken, stands outside Carl's Bakery along Camp Street in East Peoria. Carl (now deceased) and Edna Weber opened their restaurant in 1959. They purchased the giant chicken at a restaurant trade show in Chicago to promote the broasted chicken at their restaurant. Edna said the chicken came from Sparta, Wisconsin. "We bought it and brought it home on a flatbed trailer. It's the best advertisement we've ever had," she said. Here, Morton resident Paula Kestner stands next to the chicken in 2008. (Jeanette Kendall.)

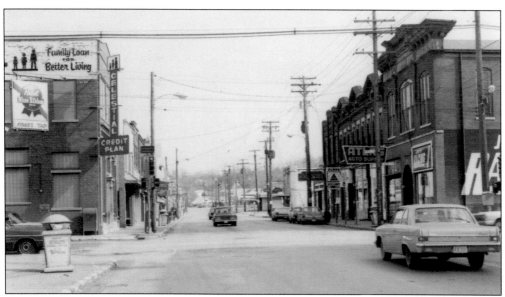

The four corners of East Peoria has always been a hot spot for business, especially in earlier days, when it was the city's original downtown. Some of the old buildings still front East Washington Street, although many along the route were razed for new developments. Today, in 2012, the businesses that sit on the four corners are East Peoria City Hall, Beck's Florist, Hardee's, and the Town Centre strip mall, where Kroger is located. The old downtown is not a hustle-and-bustle place like it was in the past, but it is still an important part of the city's history. Currently, the city of East Peoria is making new history by developing a brand-new downtown on the more than 65 vacant acres where Caterpillar's factories once stood. The photograph above, looking through the four corners down East Washington Street, appears to be from the 1960s. The photograph below was taken at the same time looking the opposite direction at the four corners, down West Washington Street. (Both, Fondulac District Library.)

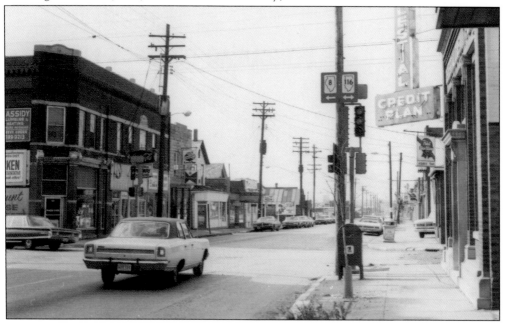

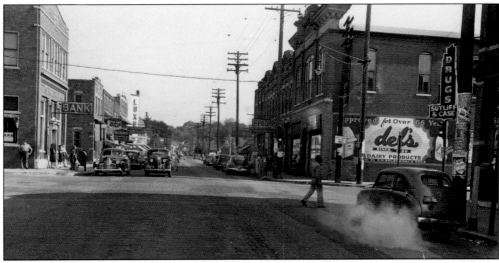

This view of the four corners is quite different than the one on the previous page, and it is from about 15 years earlier. The First National Bank, a tavern, Brownfield's Restaurant, Tazewell Savings & Loan, and the Luxe Theater are on the left. A Shell gas station, Sommerfield's Hardware, and Propp's dry goods and clothing are on the right. The street is paved with bricks. Note the posters stapled to the telephone pole at the far right. One of the posters advertises a candidate running for sheriff and another is for a concert by the Mackinaw Dells, the "sweethearts of rhythm." (East Peoria Community High School.)

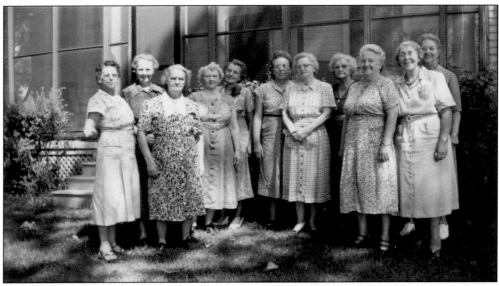

This 1952 photograph, donated to the Fondulac District Library by Eleanor M. Vale, the niece of C. Nora Kinsey, shows the SAD Club. The club was named after the initials of teacher S.A. Dennis, who taught at East Peoria Community High School. The women were all his students at one time. They are, from left to right, Eliza Sommerfield, Irene Schertz, Dora Dunn, Pamela Oetzel, Maud Lubitz Dickens, Hilda Arnold, Olive Bush, Alpha Arnold, Margaret Trindel, Laura Reffenbaugh, and Margaret Mauschbaugh. (Fondulac District Library.)

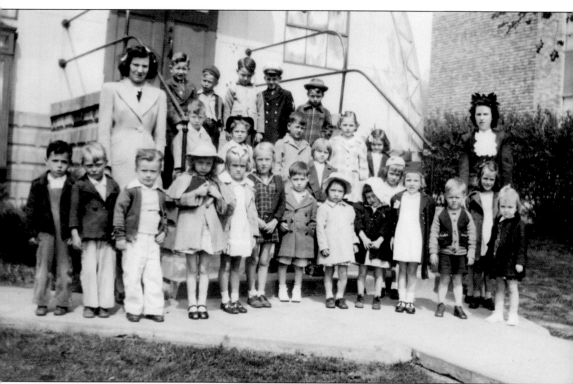

This photograph shows a Sunday school class at Bethany Missionary Church, on Leadley Avenue, likely in the late 1940s or early 1950s. The students are, from left to right, (first row) Buddy Lee, Sherman Allen, Douglas Albrecht, Mary Ellen Preston, Susie Kunkle, Atrulla Allen, Tommy Getz, Nonie White, Janet Young, Orpha Lois Silvers, Richard ?, Ila Dobbelaire, and Marcella Tompson; (second row) teacher Mary Jane Greenhood, Kenneth Ihben, Inez Reardon, Jay Young, Patsy Freeman, Jackie Clive, Linda Williams, Susie Simms, and teacher Lucille Shea; (third row) Kenneth Bloom, Carl Reardon, Harold Mitchell, Carl Cherrie, and David Cherrie. (Bethany Missionary Church.)

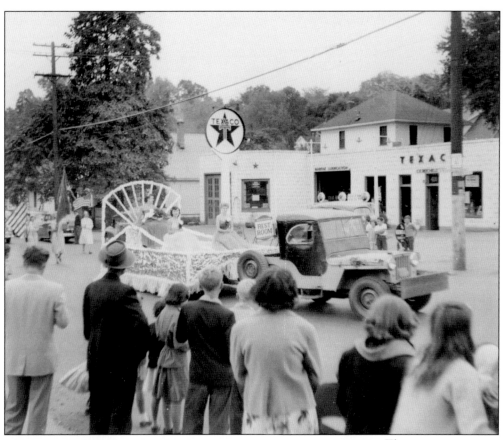

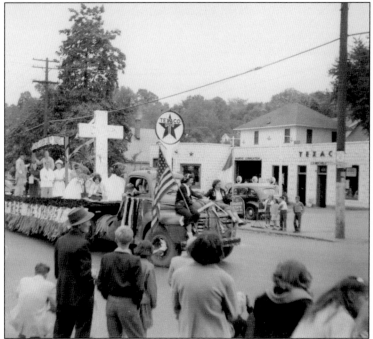

These two photographs show a parade going by the Texaco service station at 400 East Washington Street. It is believed that the parade was either for homecoming at East Peoria Community High School or for the fall festival. They appear to have been taken in the 1940s, judging by the people's clothes and the trucks used to pull the floats. (Both, Bill Schoedel.)

Four

SCHOOLS

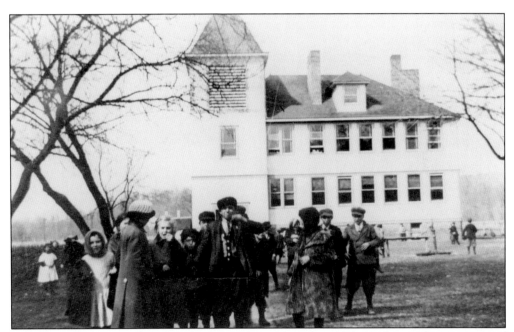

The first school reported in East Peoria was a one-room log cabin on the northwest corner of Main and Washington Streets, according to *The Centennial History of East Peoria*. A new one-room school was then built at the present site of Central Junior High School after the land was donated by David Schertz in 1850. In 1899, construction began on Central School, seen here. It was met with controversy, as many thought the new seven-room, two-story school was too big. In the fall of 1900, enrollment was at 350 students, which included grade school and high school. The school did not have indoor plumbing and students had to walk to class. This photograph was copied from a small print owned by Henry Reichelderfer of East Peoria. The negative was owned by Robert Leslie Brandstatter. (Fondulac District Library.)

This photograph shows the teachers of East Peoria's schools in the early 1900s. It was donated to the Fondulac District Library by Eleanor M. Vale, the niece of C. Nora Kinsey. (Eleanor Vale.)

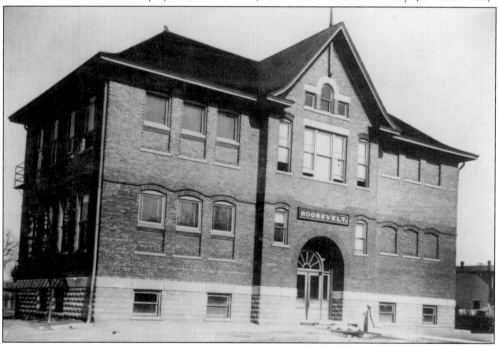

As was the case in many towns across the country, early local schools were named after American presidents. Some of the earlier schools were Roosevelt, Woodrow Wilson, and Washington. Roosevelt School, at 114 Gold Street, is seen here. It was constructed in 1905–1906. Margaret Mauschbaugh, a teacher whose career with the district spanned about 50 years, named the school, according to *The Centennial History of East Peoria*. The district's voters approved a $5,000 bond for the school's construction. It was doubled in size to eight rooms in 1924. Roosevelt School closed in 1960 and was razed. (Fondulac District Library.)

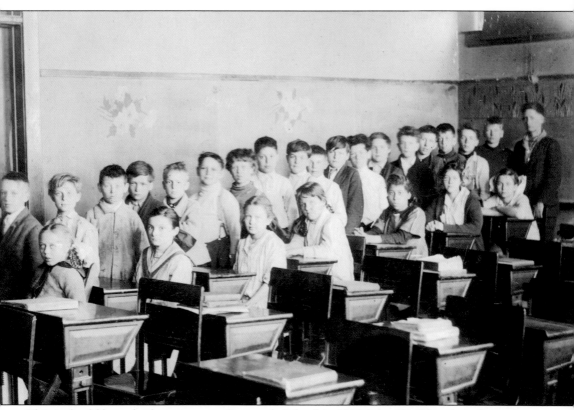

This is the fifth-grade class picture at Roosevelt School in 1916. John W. Edwards is the sixth person from the right, standing. He was born in Spring Lake Township, Illinois, on April 8, 1904, and moved to East Peoria with his family by horse and wagon around 1915. He lived in East Peoria for the rest of his life and died on February 23, 1971. (Linda Norvel.)

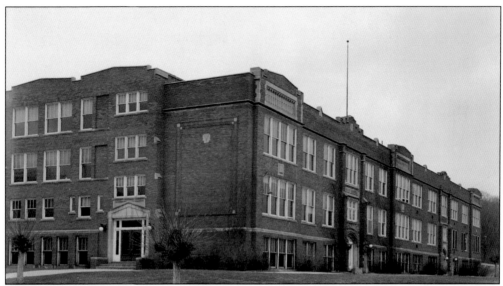

The high school separated from Central School around 1916. The new community high school was built in 1922. After 22 years of sharing space with the grade school, the high school had its own building. *The Centennial History of East Peoria* tells about the excitement surrounding the opening of the high school, which was touted as "the finest and most complete school in the country." The high school was designed by Hotchkiss & Whitmeyer and built by W.M. Allen. The construction cost about $150,000, and the building could accommodate 210 teachers. (East Peoria Community High School.)

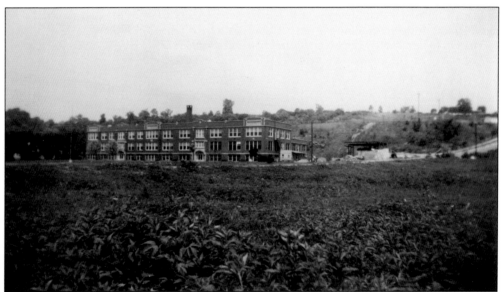

Many old-timers who attended the high school in its original building, which is now referred to as the A Building, recall that the school was located out in the middle of a cornfield. When school began in 1922, William N. Brown was the superintendent. There were nine teachers. Classes included chemistry, biology, physics, business practice, manual training, domestic science, and agriculture, in addition to the usual academic subjects, according to *The Centennial History of East Peoria*. (East Peoria Community High School.)

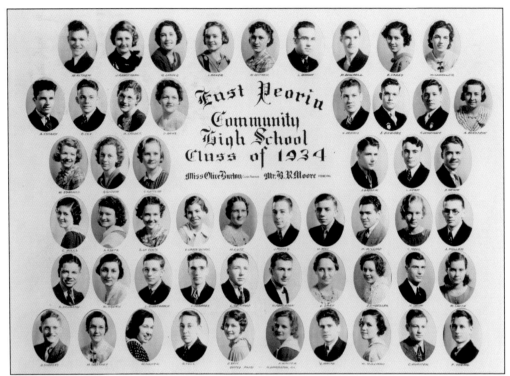

The 1934 graduating class at East Peoria Community High School is seen here. There were 53 students in the class. Olive Burton is listed as the class advisor, and B.R. Moore is listed as the principal. (East Peoria Community High School.)

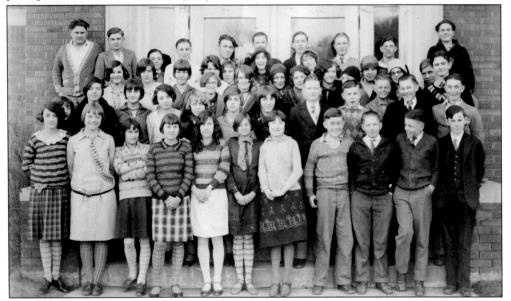

This photograph was taken in front of the main doors at the high school, probably in the 1920s or 1930s judging by the hairstyles and clothing of the students. As there were not a large number of students attending the high school at this time, this may have been the entire student body. (East Peoria Community High School.)

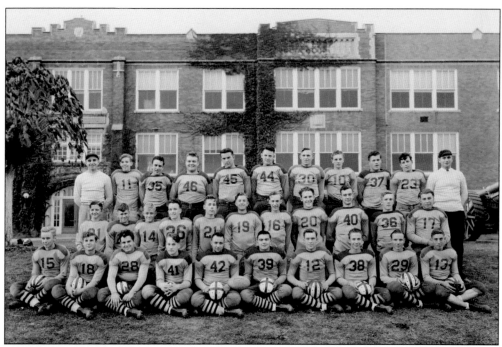

The 1940 East Peoria Community High School football team had some colorful uniforms, especially their socks. Five years before, the East Peoria football team, led by coach Harvey Stamper, were the undefeated co-champions of the Greater Peoria Grid Loop and the most successful football team in the school's history. According to the Greater Peoria Sports Hall of Fame, East Peoria tied Normal Community in its first game and then swept to victory in its last six games, finishing the season with three shutouts. (East Peoria Community High School; photograph by Camera Craft, Normal.)

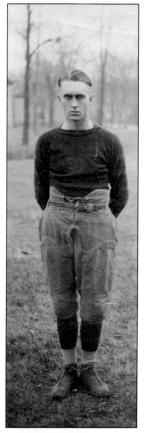

Harvey Stamper was a star athlete at East Peoria Community High School. He later became the football coach and athletic director there, leading the 1935 and 1936 teams to championships. As a student, he set records in football, basketball, and baseball. After his death due to leukemia, his widow, Maybelle Stamper, attended a ceremony at the high school in September 1941 in which the school's new football field was named after her late husband. When he became ill, Stamper surrendered his coaching duties to Clarence Allison. (East Peoria Community High School.)

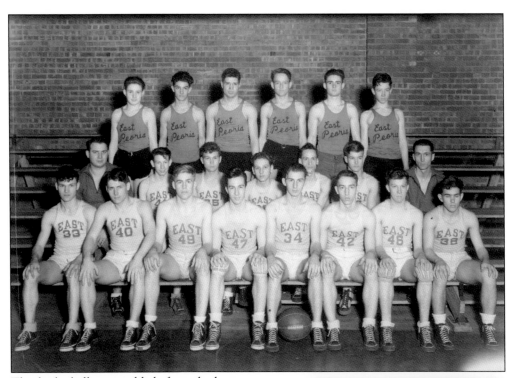

This basketball team is likely from the late 1930s or early 1940s, as they are wearing the same shoes Corwin Clatt is wearing in the photograph below. Clatt was a senior in 1940. (East Peoria Community High School.)

Corwin "Cornie" Clatt was a star athlete at East Peoria Community High School and was inducted into the Greater Peoria Sports Hall of Fame. Clatt went on to be a football standout at Notre Dame and with the National Football League's Chicago Cardinals. Like Harvey Stamper before him, he also returned to coach at East Peoria High in 1957. In Clatt's years at East Peoria, the Red Raiders had a record of 26-5-1. According to the Greater Peoria Sports Hall of Fame, when Clatt was a senior in 1940, he was on the first-team all-state team and was named the outstanding high school player in Illinois. At Notre Dame, he played on national championship teams in 1946 and 1947. The East Peoria Community High School football stadium at EastSide Centre is named after him. (East Peoria Community High School.)

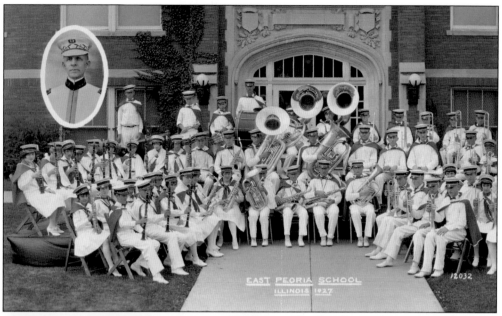

The East Peoria Community High School band is seen here in 1927. The August 22, 1928, edition of the *East Peoria Courier* wrote that the band went on its annual trip to the state fair on August 6 of that year under the direction of bandleader George Thompson. The East Peoria band won as high as second place in state contests. The article stated, "East Peoria has one of the best bands in the state and it attracts statewide attention every year." (East Peoria Community High School.)

W.N. Brown was the first principal of East Peoria Community High School. He was applauded for getting the high school accredited with the state. An article in an August 1928 edition of the *East Peoria Courier* stated that Brown's sudden death of a heart attack had school officials seeking a new principal just prior to the beginning of the school year. As soon as it was learned that the position paid $4,000 per year, applications poured in, totaling 70. In the end, the high school board promoted assistant principal Byron Moore. (East Peoria Community High School.)

Richland School was built in 1927 at 101 Globe Street. It had eight rooms and cost $88,000. An addition was built in 1947 and the school operated until 1973. According to an article in the *East Peoria Times-Courier*, the city's weekly newspaper, Robert and Myrtle Rice of East Peoria were the owners of the building from 1984, when the couple obtained it from the local United Auto Workers, until it was razed. (Jim Frey.)

Richland School was demolished in September 2010 after an inspection revealed serious structural issues. One story that was told after the demolition was that a construction worker heard a voice inside the vacant school as it was being demolished. (*East Peoria Times-Courier.*)

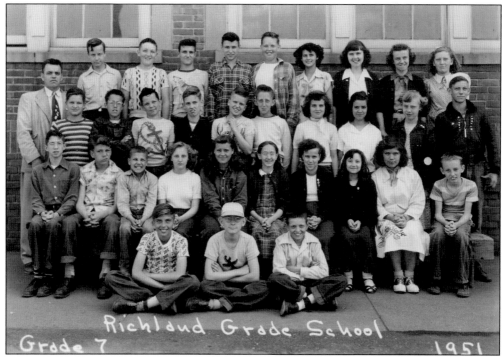

This is a class photograph from Richland School in 1951. Jim Frey is in the second row on the far right. Just before the school was razed, a class reunion was held for former students on August 28, 2010. More than 100 people attended. Some of the students also came to witness the demolition and were quoted in a 2010 article in the *East Peoria Times-Courier*. "It was the first school I ever went to," said Carolyn Scott-Sunkin, 64, of East Peoria. "They had the best lunches ever," said Rita Lappin, 44, of East Peoria. (Jim Frey.)

Washington Grade School, located at 233 Leadley Avenue, was built after World War II and was added onto in 1948. Today, the building is used by Tazewell Woodford Headstart, a preschool program for low-income families. (Peg Bahnfleth.)

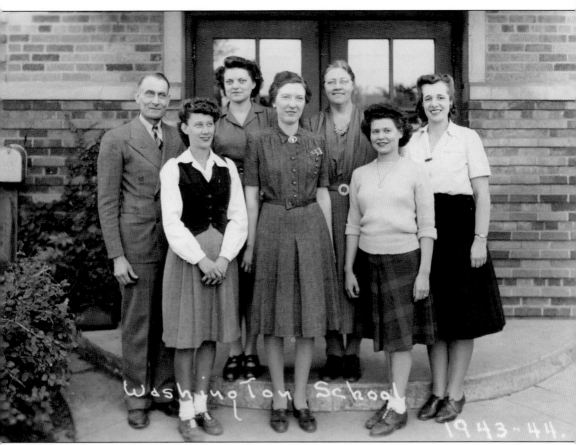

Washington Grade School teachers pose for a photograph outside the school in 1943. They are, from left to right, (first row) Peggy (Bach) Bahnfleth, third grade; Carolyn Stiers, music; Alice White, second grade; and Jean FitzHenry, fifth grade; (second row) Delmar Reinholdt, sixth grade; Florence Ralston, first grade; and Ruth Taylor, fourth grade. (Peg Bahnfleth.)

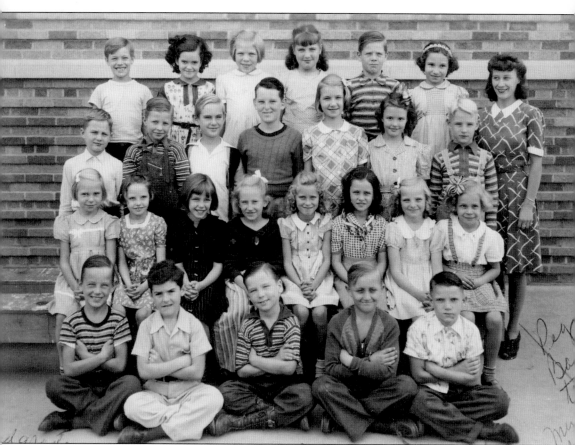

Peggy Bach graduated from East Peoria Community High School in 1939. She taught at area schools for 14 years. In 1943, at the age of 21, she taught her first class at Washington Grade School. She wrote on the back of the class photograph, "This picture was taken the latter part of September 1942–43. My first class, and am I proud!" The class included, from left to right, (first row) Don Mitzelfelt, Jerry Johnson, Nick Adkins, Ronald Davis, and Walter Johnson; (second row) Joyce Zinser, Maxine McClaskey, Erma Blair, Donna McAvoy, Barbara Brinker, Dolores Dobbelaire, Sandra Schwartzbeck, and Donna Jean Heisel; (third row) Tony Dreher, Paul Almasy, Calvin Miller, Donald Martin, Phyllis Shaver, Nancy Williams, and Roland Bowman; (fourth row) Gale Youngman, Janet Hyde, Deloris Anderson, Gay Allison, Alan White, and Carol Schmidt. (Peg Bahnfleth.)

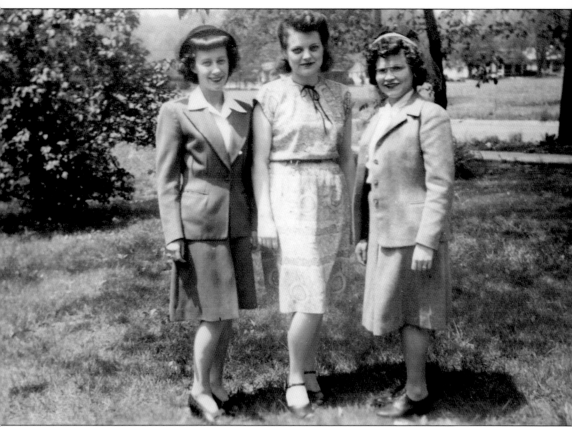

Peggy (Bach) Bahnfleth, far left, submitted this May 23, 1945, photograph of her with Florence (Ralston) Kensella and Alice (Gess) White. The three women were all schoolteachers in East Peoria. Peggy died July 2, 2013. (Peg Bahnfleth.)

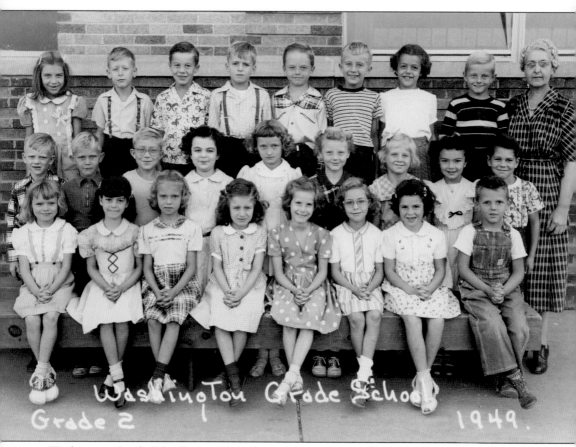

Washington Grade School's second-grade class is seen here in 1949. The class included, from left to right, (first row) Marilyn Bertha, Betty Simmons, Wanda Owens, Donna Dillenbeck, Beverly Sickles, Glenna Triplett, Marilee Eshelman, and Gary Goforth; (second row) Jack Maroney, Gary Benson, Wilburn Williams, Connie Jo Farrah, Donna McKinley, Nadine Speerli, Karen Farson, Linda Cumming, and Bill Mulholland; (third row) Anna Louise Payton, Pat Routzon, Denny Manning, Richard Rosenbush, Gene Dittmer, David Wurster, Marianne Modendricker, Gary Cordle, and teacher Mayme Solterman. (Connie Jo Farrah Habecker.)

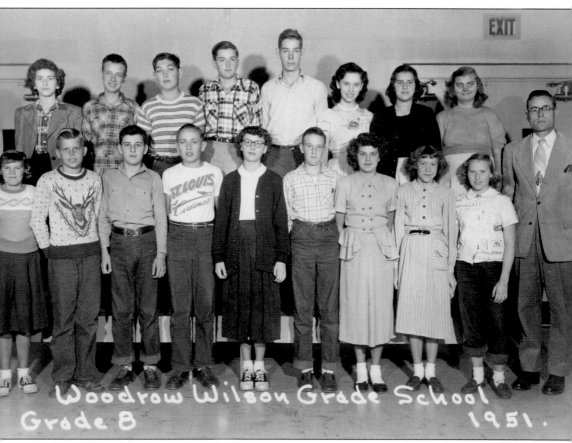

Woodrow Wilson Grade School
Grade 8 1951.

Woodrow Wilson School's eighth-grade class is seen here in 1951. Their teacher was Howard Hight. There were many changes to schools after World War II. Most schools were enlarged because of growing enrollment, and Central School even received a new gymnasium and stage, according to *The Centennial History of East Peoria*. Lincoln School, on Springfield Road, was started about 1947, and in 1949, the Highway Village School was annexed. It was replaced in 1951 with the new Woodrow Wilson School. (Betty Dobbins.)

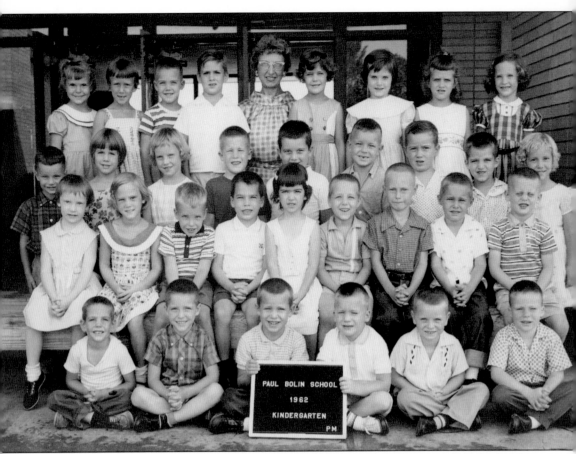

Paul Bolin was the superintendent of District 86 for 34 years, beginning in 1929. A school was named after him at the top of the Arnold Road hill. The school was built in 1954 to accommodate the rapidly expanding northeastern part of the city, according to *The Centennial History of East Peoria*. This photograph shows a kindergarten class in 1962 at Bolin School. Their teacher was Ann Goetschalk. In the back row, third from the left, is Gary Densberger, whose family operated Densberger Market. Today, Gary is a city commissioner. (Gary and Jana Densberger.)

Five

FIRE AND POLICE

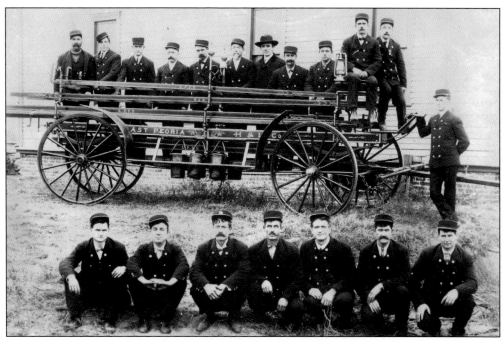

A couple of major fires led to the organization of a volunteer fire department in the city in 1903, according to *The Centennial History of East Peoria*. The East Peoria Fire Department is seen here in 1904 with a Howe H&L pump. From left to right are (first row) George Doering, William Walser, John Dean, unidentified, Henry Dean, James Preston, and William Hufeld; (second row) James Rose, William Ehrett, Henry Mauschbaugh, John Kraenbuhl, William Caldwell, William Walmsey, fire chief Beecher Reichelderfer, Louis B. Irmeger, Louis Petri, Phillip Schmidt Sr., Joe Hoffman, and William Leers. (Garry Grugan; photograph from the collection of Louis Erickson.)

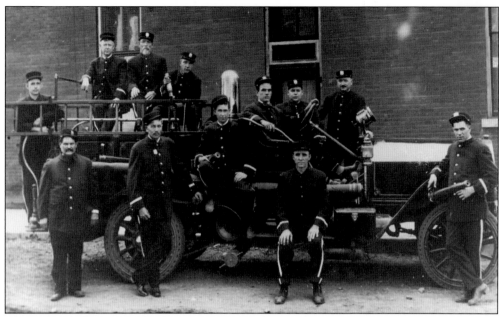

The 1913–1914 East Peoria Fire Department is seen here with a 1913 Howe pump. The department included, from left to right, (first row) Charles Barker, Mike Olson, Clarence McKensie, B.H. Reichelderfer, and Charles Vogelsang; (second row) Louis Nieukirk, Izaac McKense, William Wamsley, Joe Hoffman, John Sullivan, Jesse Hall, John Kraehenbuhl, and fire chief Louis B. Irmeger. (Garry Grugan; photograph from the collection of Louis Erickson.)

East Peoria firefighter Russell Youngman is seen here next to the department's 1941 Central DeLuxe Diamond-T pumper, which had recently been purchased for $4,486.20. The engine could pump 500 gallons of water per minute onto a fire and was in service until 1954. In 1942, Youngman and John Tull became the first full-time firefighters for East Peoria. (Garry Grugan; photograph from the collection of Louis Erickson.)

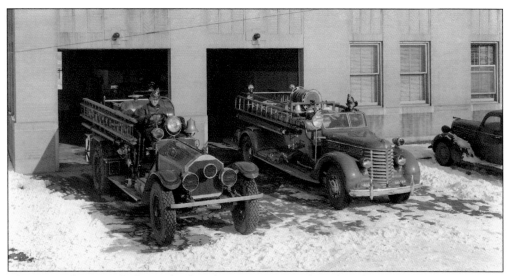

This 1941 photograph shows the fire department's two front-line fire engines in front of the recently constructed firehouse at 201 North Main Street. The 1926 American LaFrance is on the left and the department's new 1941 Diamond-T pumper is on the right. The same building also housed the police station, city hall, the courthouse, and the jail from 1939 to 1986. (Garry Grugan; photograph from the collection of Louis Erickson.)

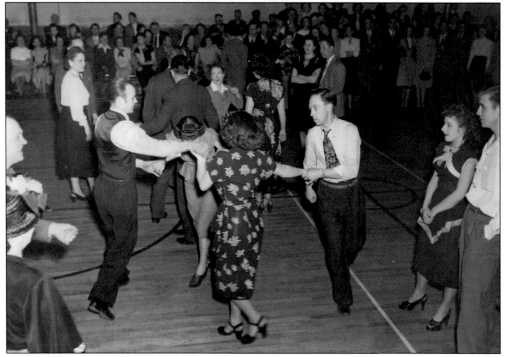

Couples dance in the East Peoria Community High School gymnasium in 1943. The East Peoria Firemen's St. Patrick's Day dance, an annual tradition from 1904 to 1966, drew a large number of the city's residents to the high school and other locations throughout the city for an evening of entertainment. All proceeds from the event were used to purchase equipment and supplies for the fire service. (Garry Grugan; photograph from the collection of Louis Erickson.)

Assistant fire chief Russell Youngman takes tickets from couples entering the East Peoria Community High School gymnasium for the annual St. Patrick's Day dance. The event featured dancing and live entertainment that was provided by Frey's orchestra for many years. "All Firemen in Uniform" and "Extra Ladies" were typically admitted for free. (Garry Grugan; photograph from the collection of Louis Erickson.)

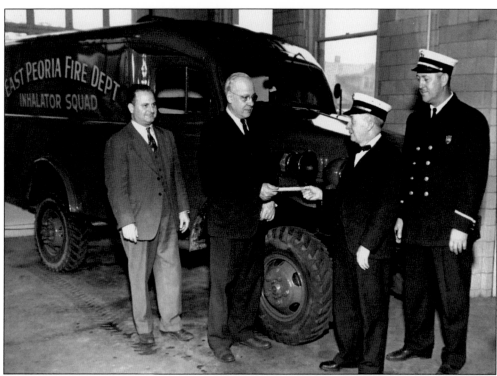

From left to right, fire commissioner Harold Schmidt and mayor William E. Sommerfield make a ceremonial presentation of a 1941 Dodge Inhalator truck to fire chief Levi King and assistant chief Russell Youngman. The truck was donated to the city of East Peoria as part of a GI surplus program and functioned as an early mobile breathing-apparatus unit for the fire department. (Garry Grugan; photograph from the collection of Louis Erickson.)

Fire chief Charles Cusac stands on the side step of the department's new 1948 Chevrolet pumper, which was purchased for $5,200. This is the only fire truck in the history of the city that was painted white. The pumper was refurbished before 1965 and repainted the typical red. It served the citizens of East Peoria until 1967. (Garry Grugan; photograph from the collection of Louis Erickson.)

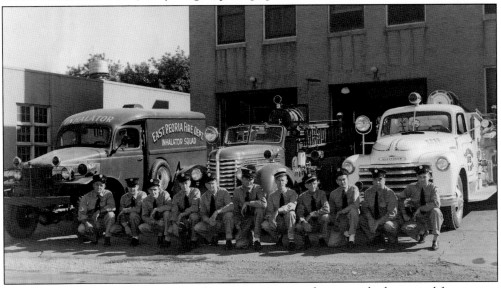

Most members of the East Peoria Fire Department are seen here outside the central fire station, along with their complete complement of fire equipment, around 1950. They are, from left to right, Armando "Ernie" Ballerini, Donald Densberger, Charles Reeser, Louis Erickson, William Bush, Abe Tennant, fire chief Charles Cusac, Mallory "Pappy" Blakely, Donald Heininger, Paul Schelm, and John Held. (Garry Grugan; photograph from the collection of Louis Erickson.)

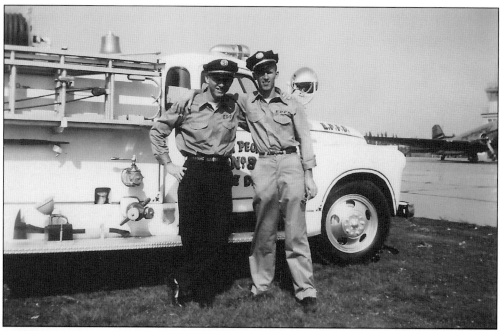

Firefighter Marvin J. Stein and fire chief Charles Cusac are seen here at the Peoria airport in 1950 along with the department's 1948 GMC pumper. Any opportunity to show off the city's firefighting equipment was usually accepted. Firefighter Stein later perished in the Green Gables Tavern fire. (Garry Grugan; photograph from the collection of Louis Erickson.)

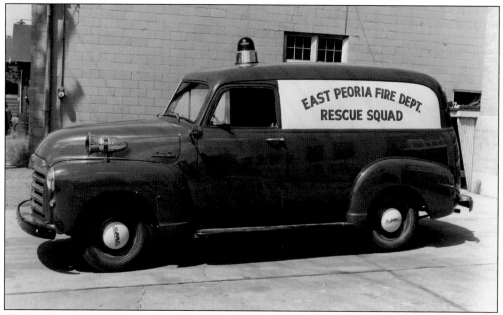

This half-ton 1952 GMC panel truck acted as the East Peoria Fire Department's rescue squad from 1952 through 1961. It is believed to be the second "rescue squad" to have operated in the city, preceded by a 1942 Nash ambulance car that was received by the city in a trade from Schmidt Undertakers. It was not until 1983 that the fire department began transporting patients to the hospital. (Garry Grugan; photograph from the collection of Louis Erickson.)

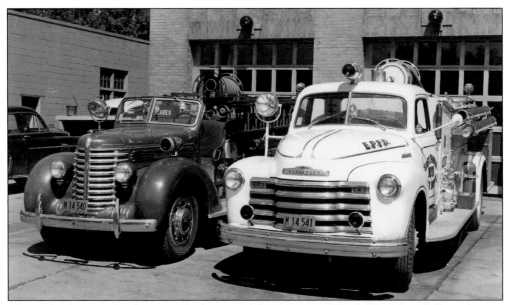

This 1952 photograph taken outside the central fire station on North Main Street shows the two fire engines that were actively serving the citizens of East Peoria at the time. The 1941 Diamond-T on the left and the 1948 Chevrolet on the right both featured prominent hose reels at the top center of their beds. The rubber-covered hose on the reels was used for most firefighting operations, unlike the double-jacketed hose of today. (Garry Grugan; photograph from the collection of Louis Erickson.)

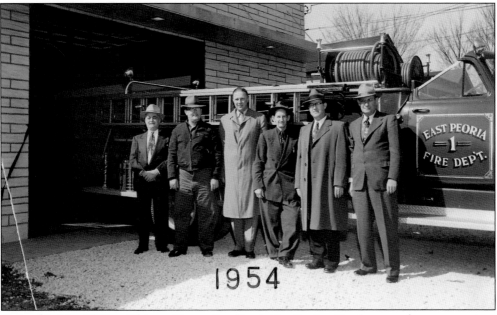

Opened in May 1954 on Chicago Street, East Peoria Fire Station No. 2 operated as a one-engine-one-man station until its closure in 1979. The building is now gone and a vacant lot is in its place. Seen here on ribbon-cutting day are, from left to right, city commissioners Charles Anthony and William Nelan, attorney Fred Stiers, commissioners John Phillips and Abe Hatfield, and mayor Ray Allison. (Garry Grugan; photograph from the collection of Louis Erickson.)

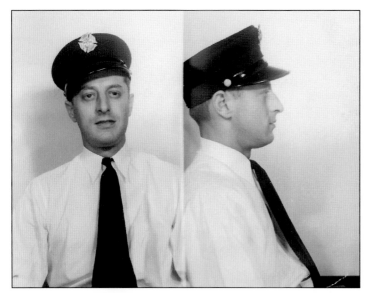

This is not a mug shot but rather the official fire department photograph for firefighter Louis Erickson from 1955. Erickson became the fire chief on September 1, 1957, and served in that capacity until May 1, 1980. He is the longest-serving fire chief in the history of the department, and many members spent their entire careers under his leadership. (Garry Grugan; photograph from the collection of Louis Erickson.)

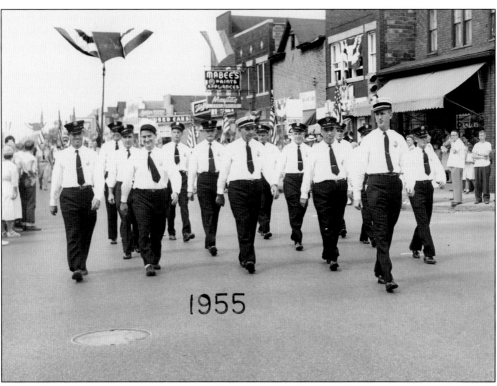

Chief Charles Cusac leads a contingent of East Peoria firefighters down Main Street (Route 29) in a 1955 parade. Most of the members at this time were still volunteers who were paid per call. The street is nearly unrecognizable today, as most of the buildings and businesses seen here have been torn down or moved to make way for new construction projects. (Garry Grugan; photograph from the collection of Louis Erickson.)

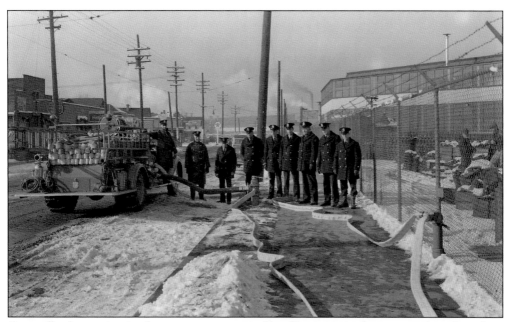

Caterpillar has maintained a strong presence in East Peoria since the company's earliest days. This 1958 photograph shows East Peoria firefighters training with Caterpillar security officers on how to supplement the factory's water supply in the event of fire. Today, Caterpillar maintains its own full-time fire department, which is assisted by the East Peoria Fire Department. (Garry Grugan; photograph from the collection of Louis Erickson.)

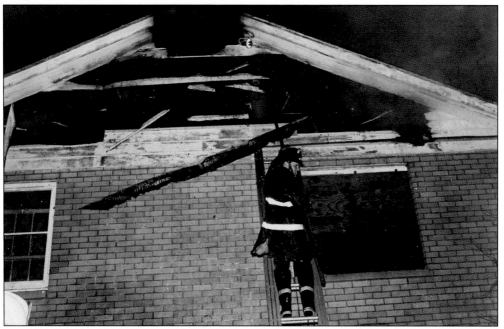

Leland and Mildred Wells owned the Green Gables Tavern on Meadows Avenue (Route 150). Mildred discovered a fire there at 9:30 p.m. on January 28, 1959. Two firefighters, assistant fire chief Marvin J. Stein and special firefighter George Cornwell Jr., died as a result of the fire. (Garry Grugan; photograph from the collection of Louis Erickson.)

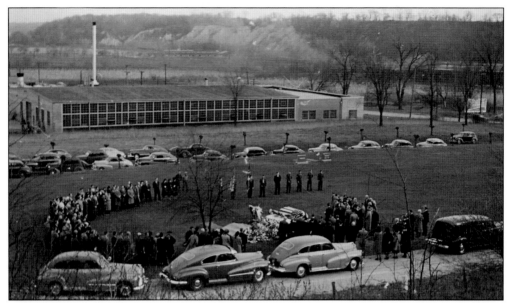

This February 1959 photograph shows the scene in the lower portion of Fondulac Cemetery as victims of the Green Gables Tavern fire are laid to rest. In addition to having served the community, both men were veterans of World War II. The services for the firefighters were held at the East Peoria Community High School, with a procession of fire trucks that followed to the cemetery, off of East Washington Street. (Garry Grugan; photograph from the collection of Louis Erickson.)

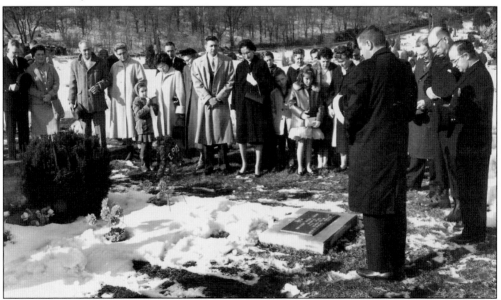

Flanked by friends, family, and coworkers, East Peoria fire chief Louis Erickson leads a memorial service at the gravesite of assistant chief Marvin J. Stein in Fondulac Cemetery. Stein and George Cornwell Jr., the two firefighters killed at the Green Gables Tavern fire, along with two other East Peoria firefighters who were killed in the line of duty, Armando "Ernie" Ballerini and William Folmar, are still honored in a yearly fire department memorial service. (Garry Grugan; photograph from the collection of Louis Erickson.)

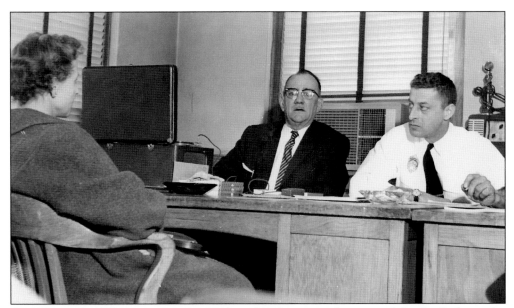

On February 2, 1959, an inquest was conducted to determine the cause of the deadly fire at the Green Gables Tavern on Meadows Avenue. Deputy state fire marshal Walter Parlier (left) and East Peoria fire chief Louis Erickson are seen here conducting an interview with a witness to the tragedy. It was determined that a sudden explosion of smoke and fire had trapped the men while they attempted to extinguish the blaze. (Garry Grugan; photograph from the collection of Louis Erickson.)

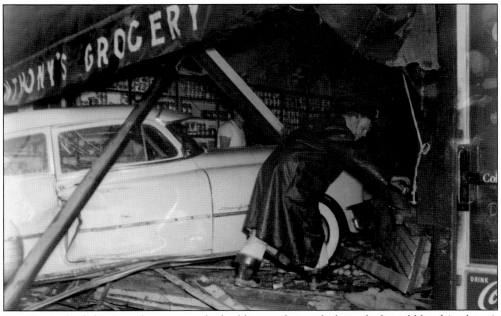

East Peoria firefighters work to secure the building as they pick through the rubble of Anthony's Grocery Store after a traffic accident that removed nearly the entire front facade in 1961. The city's firefighters are constantly exposed to new and challenging rescue situations, which continue to this day. Amazingly, most of the neatly stacked single rows of canned goods on the narrow wall shelves remained intact. (Garry Grugan; photograph from the collection of Louis Erickson.)

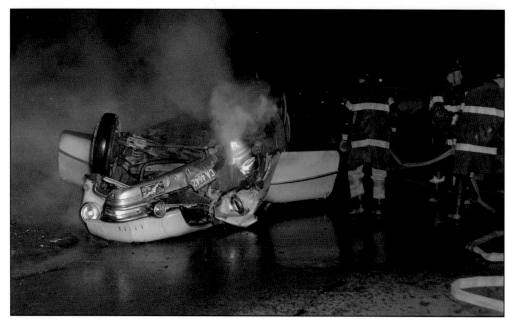

East Peoria firefighters work to put out a blaze at the scene of a car accident on February 19, 1961. The extrication tools that are familiar today were not yet available, and removing victims from wrecks like these was much more difficult. This particular intersection in East Peoria at the bottom of the Route 29 hill was known as "killer corner" due to the number of fatal traffic accidents that occurred there. (From the collection of Louis Erickson; photograph by Jerry White, WMBD-TV.)

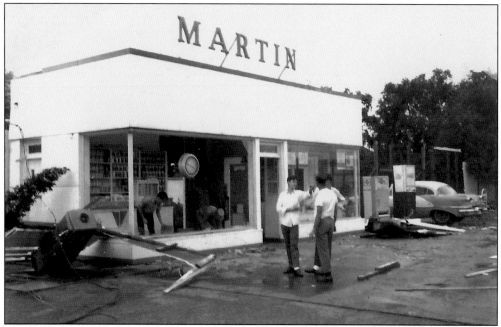

A group of young men discuss the events of the day as damage is assessed at Martin Oil on South Main Street after there were reports of a tornado coming through the area on September 14, 1965. The entire front window of the business was blown out and gas pumps and outdoor signage appear toppled and in disarray. (Garry Grugan; photograph from the collection of Louis Erickson.)

An East Peoria police officer stands by as a vehicle is removed from inside Al's Cooler Tap after a March 31, 1961, accident. The Cooler Tap has had vehicles removed from its interior on at least three separate occasions, most recently in June 2011. Fortunately, no known serious injuries have resulted from any of the incidents. (Garry Grugan; photograph from the collection of Louis Erickson.)

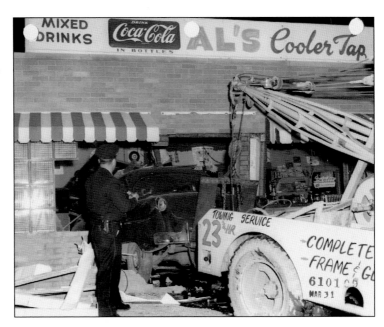

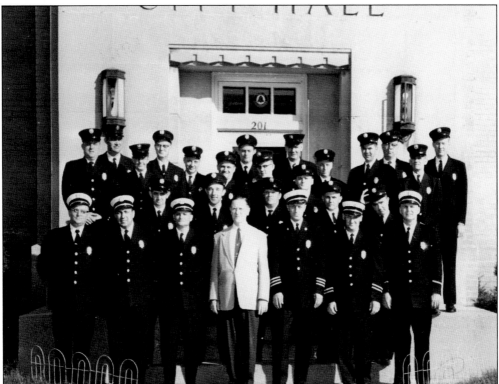

The command staff and members of the East Peoria Fire Department stand in front of the old East Peoria City Hall entrance, at 201 North Main Street, for a photograph in 1961. The building was torn down and city hall was moved to its present location in 1986, and the new central fire station opened at 201 West Washington Street the same year. (Garry Grugan; photograph from the collection of Louis Erickson.)

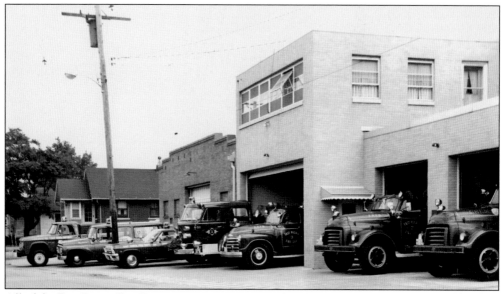

All of the East Peoria Fire Department's equipment is lined up and ready for action in 1965. The newest piece of equipment is the 1962 American LaFrance Deluxe Metropolitan triple-combination pumper, seen in the center. It operated in East Peoria until it was sold in 1982. (Garry Grugan; photograph from the collection of Louis Erickson.)

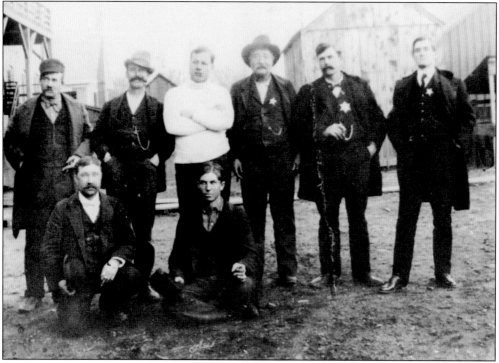

This photograph shows a very early police force in East Peoria. It included, from left to right, (first row) Hick Hoffman and George Wuester; (second row) Charles Barker, Louis Irmeger, Art Miller, Jake Mauschbaugh, Jack Maloney, and George Walmsey, president of the village of East Peoria from 1905 to 1908. (Ginger Brodt; Louis Billmeyer collection.)

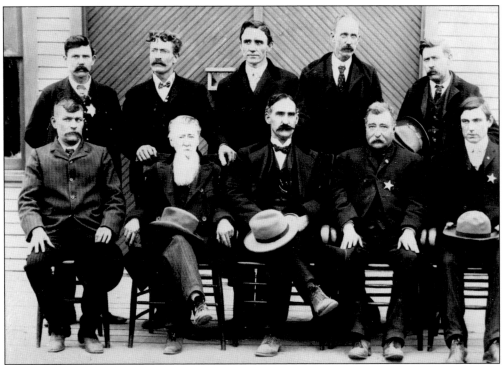

This c. 1904 photograph shows the East Peoria Village Board of Trustees, including some police and fire personnel. They are, from left to right, (first row) William Boecking, trustee; T.J. Floyd, village clerk; John Keil, president; Jacob Mauschbaugh, trustee; and George Walmsley; (second row) John Maloney, village marshal; John Dean, trustee; Beecher H. Reichelderfer, trustee; J.R. Dickens, trustee; and Frank Dainty, police magistrate. (Fondulac District Library, Louis Erickson collection.)

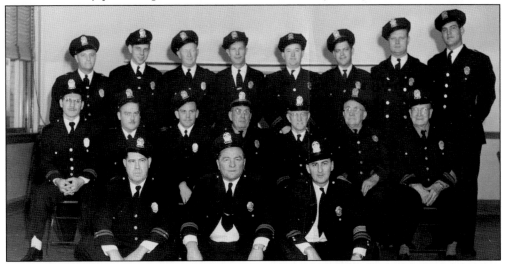

The 1949 East Peoria Police Department included, from left to right, (first row) Keith Misecher, John Buttas, and Vernie Roberson; (second row) Sam Pendola, Marvin Upphole, Al Fugate, Lloyd McCollum, James Harvey, Beecher Reichelderfer, and John Dean; (third row) Elwood Stafford, Elmer Sandifar, Jess McKenzie, Bill Payne, Lud Ludlem, Melvin Hoshor, Henry Johnson, and Frank Andrews. (East Peoria Historical Society.)

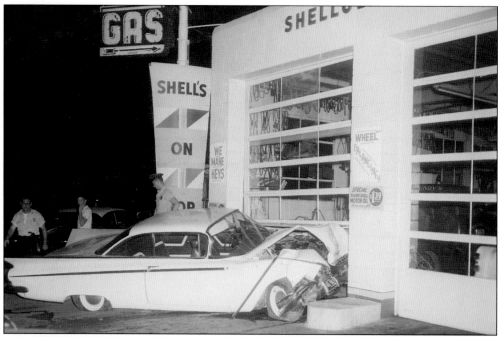

Retired East Peoria police officer Bill Martin submitted this photograph of a wreck at Boundy's service station, at 1017 East Washington Street. According to a newspaper article, Alice Zimmerman, 42, of 200 Pershing Place in East Peoria, was treated for a head injury at St. Francis Hospital after she lost control of her automobile, struck a curb, and crashed through a garage door at the service station. (Bill Martin.)

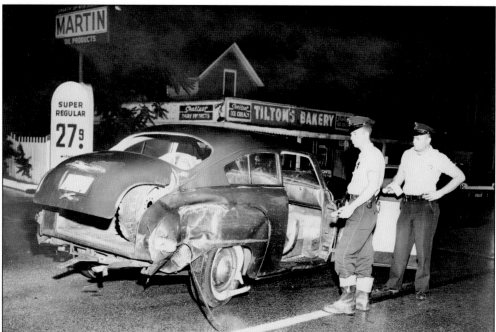

East Peoria Police respond to a car wreck in front of Tilton's Bakery at 216 South Main Street in June 1958. Two people died in the accident. (Bill Martin.)

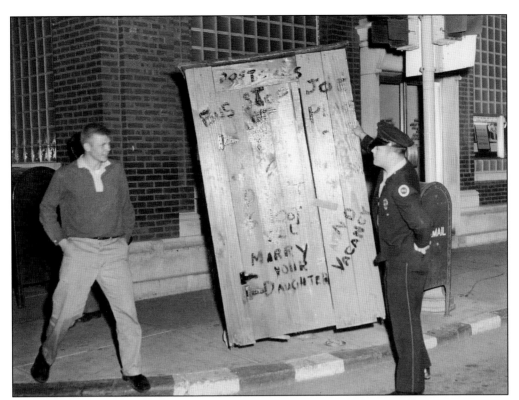

East Peoria police officer Bill Martin is seen here with a stolen outhouse. Pranksters stole the outhouse from Cole Street and placed it on the four corners of downtown East Peoria as a Halloween prank. They wrote "bus stop" and "no vacancy" on the front of the outhouse, among other things. In the background is the First National Bank. (Bill Martin.)

Bill Martin was an officer for the East Peoria Police Department from 1956 to 1982. During his time on the force, he was held at gunpoint three times, shot at once, and forced to shoot a bank robber. He received many commendations during his career. He also collected photographs and news clippings from his time on the force and kept them in scrapbooks and boxes. He is seen here in 1977. (Bill Martin.)

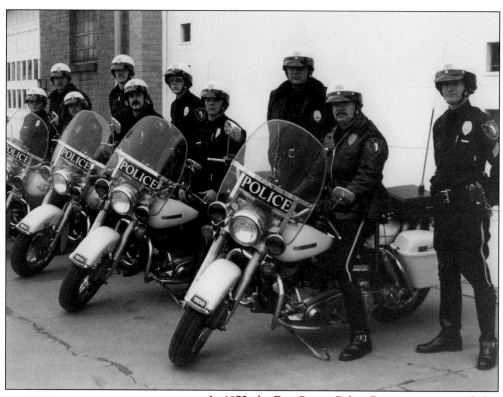

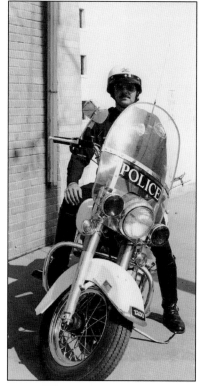

In 1975, the East Peoria Police Department expanded with a highway safety federal grant for a motorcycle traffic bureau. According to a November 2012 article in the *East Peoria Times-Courier*, five motorcycles were purchased and 13 men were hired to join the force. Some veterans and many new hires made up the unit. Pictured from left to right are (first row) Chris Lavin, Leo Sanders, Kenny Todd, Craig Carlson, and Dave Glover; (second row) Steve Deatherage, Rick Higgs, David Arterberry, Mike Kumer, and William Bahnfleth, the sergeant of the traffic division. Not pictured is Dick Lamb. (Kenny Todd.)

The 1975 motorcycle unit was short-lived, only lasting for about one year. Many of the officers were laid off and then eventually called back to work. The city council voted them in with a 3-2 vote and voted them out with a 3-2 vote, according to former officer Dave Glover, who is seen here on one of the 1975 Harley-Davidsons. The police department started a motorcycle patrol unit in 2012 with two motorcycles. Officers Dave Sprague and Scot Craig were selected as the motorcycle officers. (Dave Glover.)

Six

DEVELOPMENT

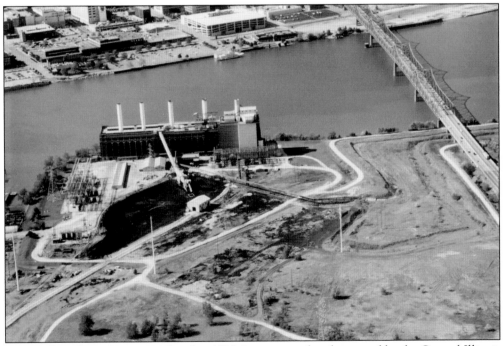

R.S. Wallace Station was completed in 1925. It was owned and operated by the Central Illinois Light Company (CILCO) and located along the Illinois River. CILCO described its plant as "the giant of the Illinois." According to the East Peoria Historical Society, after its completion, more than 16,000 people toured the facility. Locals likely remember the "Reddy Kilowatt" sign that was on the side of the building facing Interstate 74. In 1958, when it was installed, the illuminated sign was the largest in the state. This photograph of Wallace Station was taken on May 27, 1994. (Gary Matthews.)

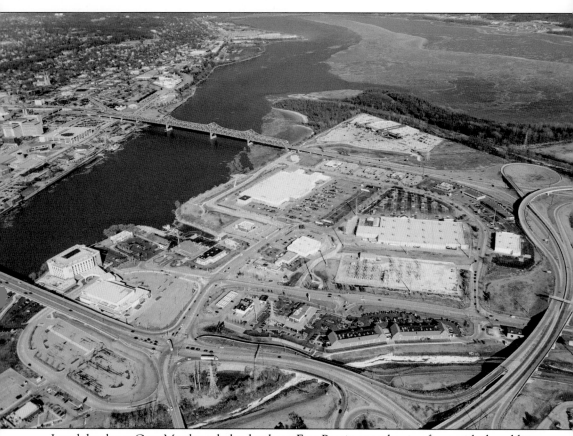

Local developer Gary Matthews helped reshape East Peoria near the riverfront with the addition of Walmart, Lowe's, Office Max, PetSmart and more. Walmart closed its store in East Peoria at Town Centre I and built a 200,000-square-foot Walmart Supercenter along the river in an area that was formerly a garbage dump. The store opened in 1997. The land where Wallace Station once sat was donated to the city for a riverfront park. (Dennis Sievers.)

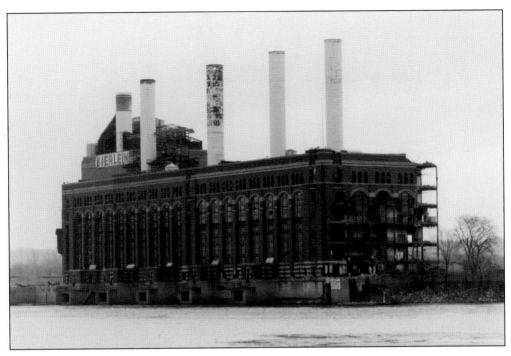

To make room for a development called Riverside Center, Wallace Station was demolished on December 17, 1995. The plant had been closed since 1985. This series of photographs, taken by local professional photographer Dennis Sievers, shows the demolition. Even though it was a brisk day, hundreds came to watch the implosion from the Peoria side of the river. After a series of booms that sounded like firecrackers, the building was gone. (Both, Dennis Sievers.)

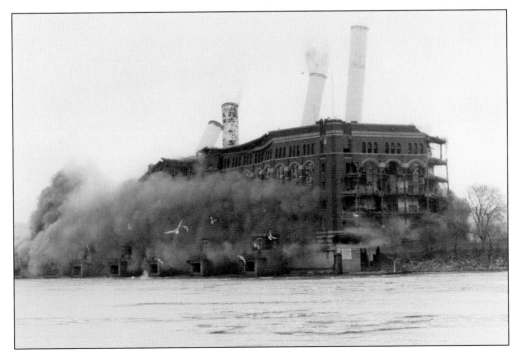

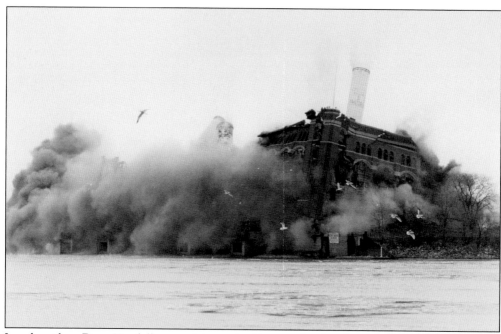

Local resident Dean Kendall wrote this mock obituary after he photographed the implosion of Wallace Station. "Wallace Station, 70, of Peoria, died at 9:00 a.m. Sunday, December 17, 1995. At the banks of the Illinois River, she was imploded with a series of blasts at seven second intervals, East to West, systematically blasted away, left in a heap of debris and smoke, her smokestacks lying in a helter-skelter pattern, twisted metal, piles of bricks, once the backbone of this old landmark, in an instant reduced to a 'pile of bricks'. She will now be buried forever, a memory of another time. Memorials may be made to the Walmart Corporation." (Both, Dennis Sievers.)

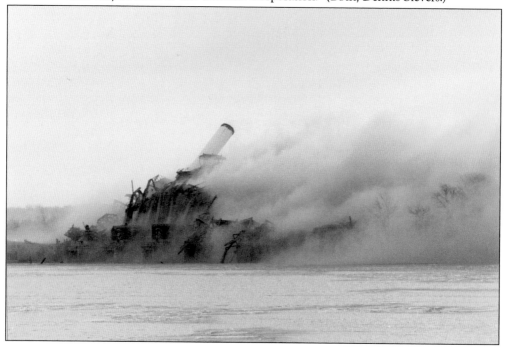

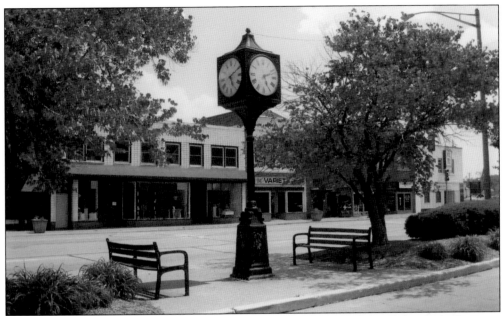

This old-fashioned clock sits on the edge of Town Centre I. At the base of the clock, there is a plaque that reads, "The Joseph Company's contribution to East Peoria Downtown Redevelopment 1984. David S. Joseph. Maurice B. Joseph. Leonce F. Joseph." Local developer Gary Matthews said that Town Centre I and Town Centre II were the first retail shopping plazas in East Peoria. (Jeanette Kendall.)

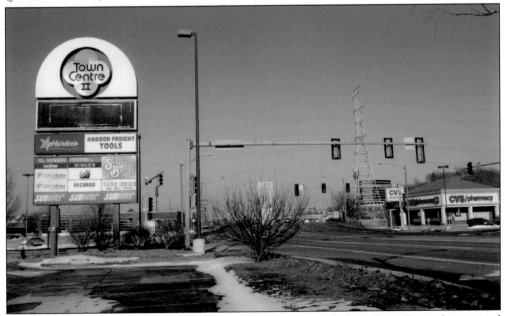

Town Centre II, located directly across Main Street and diagonally from Town Centre I, contained a major anchor in Walmart, with other shops located in a strip. The Walmart at 105 North Main Street, in Town Centre II, was built in 1987. Just 10 years later, a Walmart Supercenter was built, taking the place of the original store. After Walmart vacated its original building, ShopKo moved in. The building is now vacant. (Jeanette Kendall.)

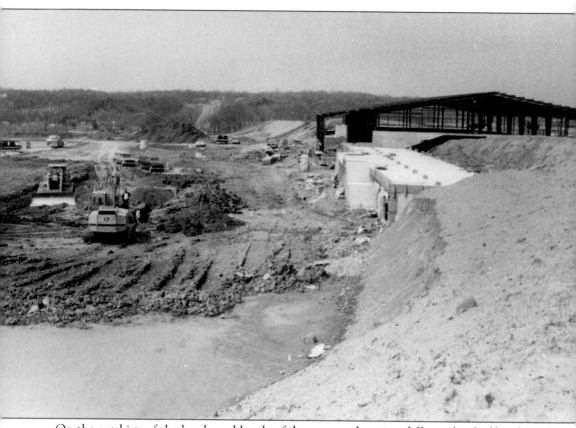

On the outskirts of the hustle and bustle of downtown, there is a different kind of hustle and bustle at the EastSide Centre sports complex. The development occurred on property that was previously a gravel pit. According to a 1996 *East Peoria Courier* article, this photograph shows construction work on the stadium at the sports complex. The frame in the background became the recreation building. Portions of EastSide Centre opened in 1996. (*East Peoria Courier.*)

This photograph shows the inside of the recreation building, where people can work out by walking the indoor track, using the various exercise equipment, or taking an exercise class. In addition to the recreation building, EastSide Centre also includes Corwin Clatt Stadium and Splashdown water park. EastSide Centre is owned and operated by the City of East Peoria, East Peoria Community High School, and the Fon du Lac Park District. (Jeanette Kendall.)

Near Walmart sits one of East Peoria's proudest developments, Bass Pro Shops. The shop sits on 35 acres of what was once known as the CILCO Ash Pond. This aerial photograph taken by local commercial photographer Dennis Sievers shows the crowd of more than 6,000 people waiting to get inside the store on opening day. Bass Pro Shops/Outdoor World opened in September 2011

with an Evening for Conservation fundraiser. Celebrity guests, including NASCAR drivers Jamie McMurray and Tony Stewart, were on hand to celebrate the grand opening. Bass Pro Shops features an indoor bowling alley, a restaurant, an aquarium, a general store, and many other departments for outdoor needs. (Dennis Sievers.)

The Par-A-Dice Riverboat Casino took its first cruise from East Peoria in May 1993. The original boat was a paddle-wheel style, as seen here. The Par-A-Dice is behind the *Spirit of Peoria*, coming under the Franklin Street Bridge. A new, larger $22 million Par-A-Dice Riverboat Casino arrived in East Peoria in May 1994, according to the *East Peoria Courier*. The Par-A-Dice is now docked along the Illinois River. (*East Peoria Courier.*)

Harbor Pointe, the residential portion of EastPort Marina located along Route 116 in East Peoria, opened in 1996. Prudential Cullinan Properties Ltd. developed the residential condominiums. The city of East Peoria developed the marina and related facilities, according to a May 22, 1996, news article in the *East Peoria Courier*. (*East Peoria Courier.*)

The landscape in downtown East Peoria was heavily dominated by industrial businesses, as seen in this 1997 photograph. Caterpillar's factories occupied much of the acreage in the heart of East Peoria. More than a decade later, this landscape drastically changed as Caterpillar shut down some of its factories and demolished them. (Dennis Sievers.)

After the closure of some Caterpillar factories in downtown East Peoria, the city was afforded a unique opportunity to recreate its image with an entirely new downtown. A blank slate was available, in the form of more than 85 acres of property. This is the downtown as it appears today. The new downtown, named the Levee District, was a project in the making for more than a decade. In 2013, it was still under development. Shops that have located there include Costco, Gordmans, and Target. (Dennis Sievers.)

Cullinan Properties Ltd. was named the master developer of the Levee District. The project is the largest retail development in the city's history. Cullinan conducted a steel-beam-raising ceremony in the summer of 2012. Mayor Dave Mingus and Cullinan officials spoke at the ceremony. In addition to large retail giants such as Costco, Gordmans, and Target, the Levee District will also house a new Fondulac District Library, city hall, Holiday Inn & Suites, and Clock Tower Place. (Jeanette Kendall.)

This strip of buildings was under construction in early 2013. These buildings will be filled with new businesses that are a part of the Levee District in downtown East Peoria. Also anchored within the Levee District are Gordmans, Costco, Target, and ULTA Beauty. (Jeanette Kendall.)

Long ago, this would have been considered the "new" downtown of East Peoria. Today, these buildings, seen here in 2013, are some of the oldest buildings left in the city, located along East Washington Street. This strip of buildings once housed the Blue Bird Theatre, Levi S. King's Barbershop, John Dean's, and more. Some of the remnants of old businesses are still visible today. One of these longtime businesses, the Bamboo Inn, closed in February 2013. Just down the road, along West Washington Street, is the city's new downtown, which residents will enjoy for decades to come, just as those before them enjoyed the downtown businesses of yesteryear. (Jeanette Kendall.)

DISCOVER THOUSANDS OF LOCAL HISTORY BOOKS FEATURING MILLIONS OF VINTAGE IMAGES

Arcadia Publishing, the leading local history publisher in the United States, is committed to making history accessible and meaningful through publishing books that celebrate and preserve the heritage of America's people and places.

Find more books like this at
www.arcadiapublishing.com

Search for your hometown history, your old stomping grounds, and even your favorite sports team.